BEGINNER'S GUIDE TO

DIGITAL IMAGING

for photographers and other creative types

ROB SHEPPARD

Editor, *PCPhoto* magazine

AMHERST MEDIA, INC. ■ BUFFALO, NY

Published by:
Amherst Media, Inc.
P.O. Box 586
Buffalo, N.Y. 14226
Fax: 716-874-4508
www.AmherstMedia.com

Publisher: Craig Alesse
Senior Editor/Production Manager: Michelle Perkins
Assistant Editor: Barbara A. Lynch-Johnt

ISBN: 1-58428-078-6
Library of Congress Control Number: 2001133140

Printed in Korea.
10 9 8 7 6 5 4 3 2 1

TABLE OF CONTENTS

INTRODUCTION

Film is dead! Long live film! While a lot of people seem to need to resolve the film vs. digital capture debate, this book is designed to look at the positive ways the computer can be used to enhance everyone's photographic experience, regardless of whether the original image started on film or an image sensor. I want to give you practical, real-world advice on how to choose and use the new technologies, no matter what your preferences are.

Most photographers are discovering that the computer can revitalize their picture taking. I find this to be a consistent refrain, even among those who took a long time to check out what the computer can offer for photography. You, too, will find that scanners will bring more out of your traditional photos than ever seen in prints before; that digital cameras add excitement and spontaneity to shooting; that working on an image in the new darkroom, the digital darkroom, can be addicting (be prepared for late nights where you want to do "just one more thing"); that inkjet prints from your desktop can be better than anything you get from the traditional minilab (and that good digital minil-

Before (above) and after (left). The new darkroom, the digital darkroom, offers photographers wonderful control over their images.

The way images are captured is changing, but the traditions of good photography, from exposure to composition, have not.

abs can give you better prints, too); and that the web offers some fantastic things for the photographer.

There is no question that the computer has revolutionized photography. When digital photography first started getting attention, it wasn't always positive. Frankly, a lot of early use of the computer with photography did not produce enhancements that photographers actually wanted in photographs. That was because the early users tended to be commercial folk such as art direc-

tors and designers at media companies (ad agencies to publications) who could afford the very high prices for equipment. We saw the moving pyramids, strange composites of images and, often, a lack of respect for the photographer's work. A lot of designers, frankly, see photography as just another element to play with in a design.

When RAM prices dropped and inkjet printers achieved photo quality, things started to change dramatically. Photographers got excited because they could use the digital technologies to get the most out of their images. This ranged from adjusting a color image in a traditional darkroom fashion to creating whimsical, fun scenes and actions that existed only in the photographer's head.

Today, with high processing power available at low prices, scanners for every budget and need, and digital cameras getting better and cheaper, all photographers are truly in a great position to use these tools to improve and enhance their own photography.

In my experience as editor of *PCPhoto* and *Outdoor Photographer* magazines, I have learned a lot about the new technologies and how many photographers are applying them to their work. In my workshops and classes, I have been blessed with a lot of great students who have helped me discover exactly what they need to know about the changes taking place in photography.

This book reflects both of those experiences. It doesn't cover everything, but in my experience, throwing everything at people tends to be more overwhelming than helpful. I have tried to give you ideas, tips, and concepts that I have found really work for photographers. I

In the computer, you can do everything from adjusting color in a landscape photo to creating images of whimsy.

have little interest in all of this technology if it only adds more power to my computer. Like you, I want it to do something for my photography. In this book, I will help you make better use of the digital tools to make your photography better, too.

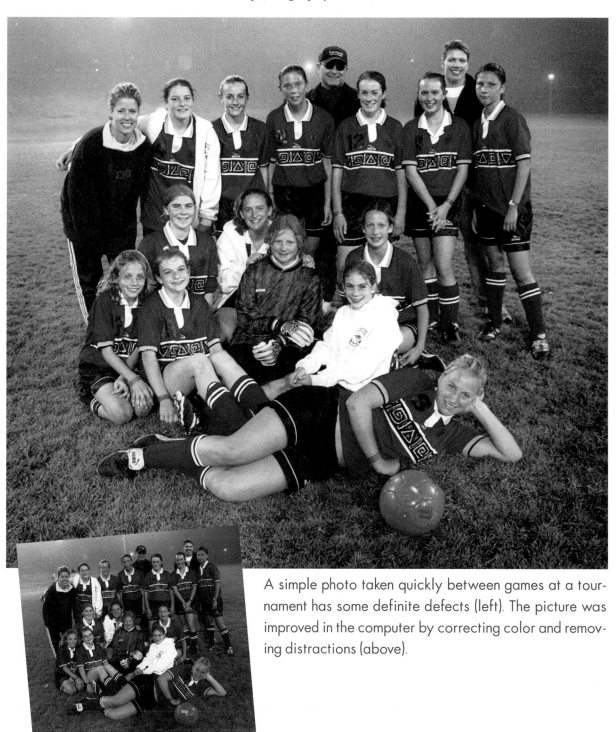

A simple photo taken quickly between games at a tournament has some definite defects (left). The picture was improved in the computer by correcting color and removing distractions (above).

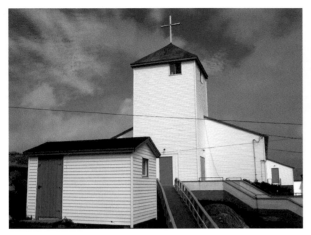

The computer allows photographers to clean up images so the real subject can shine, such as this church in Ramea, Newfoundland.

This Arizona desert scene felt warmer and more colorful than what the film recorded. A little work in an image-processing program brought out better color and detail.

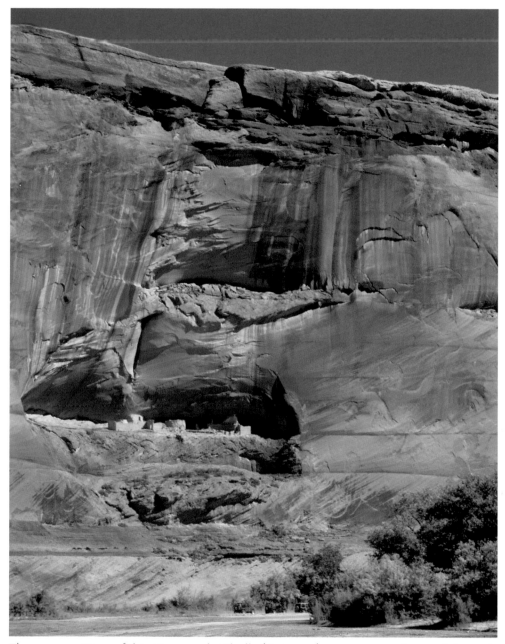

The composition of this Canyon de Chelly (Arizona) scene was enhanced through shooting with a digital camera and checking relationships of vehicles, ruins, rock and sky on the LCD monitor.

COMPUTER NEEDS
FOR THE PHOTOGRAPHER

For most photographers, the computer is the least inter-esting part of the digital equation. Yet, if you don't have the right equipment for the job, you will find the fun photo stuff is a lot less fun. It will too often be frustrat-

A good computer for photography is not simply a matter of the latest and greatest. Critical needs are enough RAM (minimum 128MB) and a large monitor (at least a 17-inch model— and a 19-inch model is better).

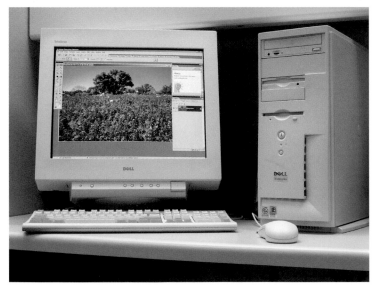

While the purists will haggle, you'll get great results with both Windows and Mac computers. The choice comes down to software needs, friends and personal aesthetics.

ing and could lead to crashes and lockups, which are no fun at all. So, to get started in our quest for better images using the computer, let's look at the computer and its peripherals as they relate to the photographer.

▷ MACINTOSH® VS. WINDOWS®

In spite of enthusiasts' rants, there is no significant difference between a Macintosh (Mac) and a Windows computer as far as photos go. The images don't care. And you won't find any real differences that will affect your photography. Still, there are reasons for selecting one platform over another:

1. **Software Needs.** If you need something specific, be sure that it will work on your platform. A lot of low-end imaging and design software, for example, only works on Windows.

2. **Circle of Friends.** Buy the platform that most of your friends (or workplace) use(s). That way, if you run into problems (and you will), you will have people to go to for help. If your computer is the odd one, who do you turn to?

3. **Aesthetics.** Sometimes a certain computer just looks better to you. Since photographers are visual folk, that really isn't a dumb consideration. Why not have a computer and screen that you enjoy the look of?

▷ RAM

If you go down to the local computer store or read the ads by computer manufacturers, you would be convinced that computer processor speed is the key and worth spending extra for (and this extends to the Mac vs. Windows debate). However, for photos, the key is random access memory (RAM). If you don't have enough RAM, your computer processor will be twiddling its digital thumbs waiting for data to process. Low RAM can also make you more susceptible to crashes.

Photographers should have a bare minimum of 128 MB of RAM, and this truly is a minimum. Go higher, if you can. If you want to work with large files (8x10 or larger in a final print size) or panoramics or special effects, consider 256 MB a basic requirement and go up from there. If you have to skimp on a purchase because of cost, go for the slower processor and add RAM.

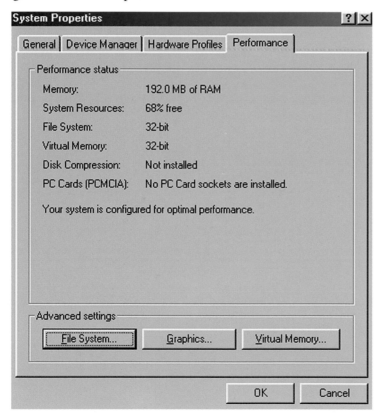

If you aren't sure how much RAM you have, check your system's properties. Anything less than 128MB will make your computer slower and more susceptible to crashes when working on photos.

▷ Hard Drive

Modern hard drives are big and fast—two characteristics that offer benefits to the photographer. Image files can quickly take up space on a hard drive, so having multi-gigabytes is important. Speed can be an asset because big image files will open and save faster with a fast drive.

Hard drives have come down so much in price that for many photographers, it is well worth getting a second drive. This gives you additional storage space, plus you can be sure this drive is fast. But you may already have a big drive and figure a second drive is not needed. Think again. That second drive is the cheapest insurance you can get for your images. Just copy over all of your photo files and all your hard work is backed up.

Finally, keep in mind that all image processing programs need hard drive space to park information not being used at the moment, but needed for work on an image (such as undo's and any history of your actions). You need to have at least 200 megabytes (MB) free space on your drive for this purpose, and for many photographers, 1 gigabyte (G) is a better number. A fast hard drive improves the way your computer works, too.

Hard drives have come down in price while at the same time increasing in capacity (this photo shows the inner workings of a hard drive). Adding a second hard drive to your computer is an excellent choice for backup and increased photo file storage.

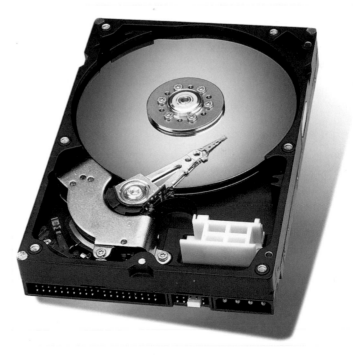

▷ MONITOR

Do yourself a favor and buy at least a 19-inch monitor. You can get by with a smaller unit (17 inches), but having that extra screen space is such a joy when you are working with photos. A lot of the screen is taken up by the "interface" of the software (the controls panels, dialogue boxes, etc.), so having more space available allows your photo to be bigger on the screen. Twenty-one inch and larger monitors are fantastic, but they jump up quite a bit more in price and take up a lot of desk space. Look for the compact models of any size.

LCD screens are sleek, take up little space, and are very cool. On the other hand, they do add a bit to the price of a monitor, not everyone likes looking at images on them, and they are harder to deal with concerning color.

▷ STORAGE PERIPHERALS

Photographers need to have several peripherals (either add-on or built-in) with their computer that will help make the photo storage easier. To start, a CD writer (or "burner") has become almost a necessity. With this, you can back up photo files, store images safely, deliver photos to others (including such things as self-playing slide shows), and more, all on a CD. Using a CD offers two great advantages: it has a great capacity (over 600 MB of data), and almost every computer has a drive that will read a CD.

There are two types of CD media that can be used for recording data: CD-R (recordable) and CD-RW (rewritable). The "CD-R only" drive has nearly disappeared from the market because CD-RW units will record to both types of media. CD-Rs can be written to only once. Once full, they cannot be erased and reused. CD-RWs can be written to, then erased and reused later.

Flat-screen LCD monitors are sleek, take up little space and are becoming increasingly popular. However, some photographers find they are not as easy to use for image adjustments as the standard CRT monitor.

A CD writer or "burner" is an important part of a photographer's computer setup.

When using CDs for storing photos, buy quality media from well-known companies. CD-R and CD-RW media are not all the same. In addition, the media used for CD-Rs is more stable than CD-RW (which makes sense since the latter is not designed to be "stable," i.e., it can be changed by erasing). The most archival CD-R disks are generally touted as such and do cost more. Whatever you do, don't buy the cheap "too-many-for-the-price" disks—there is a good chance you will be disappointed in their performance for photo image files (especially in their longevity).

Zip drives are another important accessory. These have become a rather ubiquitous part of the industry. They allow you to put images on and off a removable disk as desired, acting like any other magnetic drive (such as your hard drive). However, also like all other magnetic media, they do not have archival qualities. Data will fade, often within ten years. The big advantage of a Zip is the convenience of quickly putting images onto a 100 or 250 MB disk, then taking them somewhere and being able to work on the images and resave to the disk. They are quicker and easier to use than a CD, but they have less capacity.

When using CDs for storing photos, buy quality media from well-known companies.

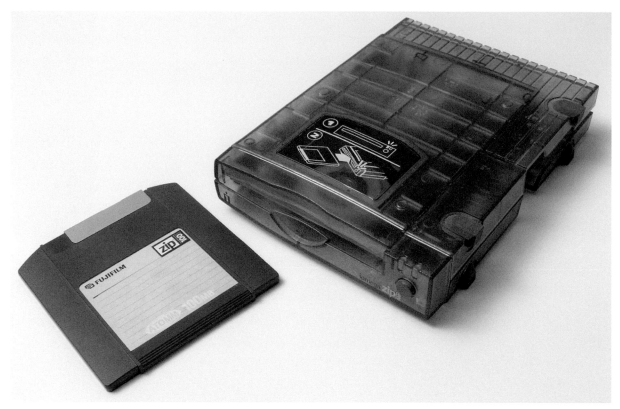

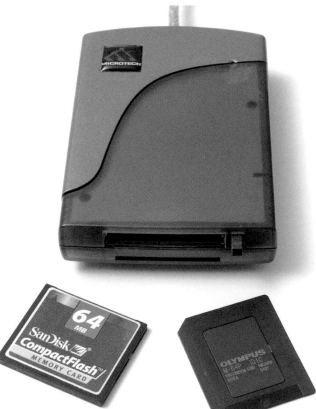

Zip disks (with drive above) are a common part of the photo industry and offer very flexible storage for your computer. Memory card readers (left) should be considered an essential peripheral if you have a digital camera.

A key peripheral

for anyono

with a digital camera

is a card reader.

A key peripheral for anyone with a digital camera is a card reader. With this little device, you simply take the memory card from your camera, plug it into the reader, and the computer sees the card as another drive. You then drag and drop files from the card to a folder on your hard drive. This makes it very easy as you don't have to deal with plugging cables in and out of your computer to get at the photos. In addition, these readers are generally much faster than downloading from the camera itself.

▶ 2
CHOOSING AND USING DIGITAL CAMERAS

Digital cameras have finally become viable, quality picture-taking tools. You can easily take photos today with digital cameras that will rival and match traditional film. Camera manufacturers constantly bring out new digital camera models. While this may seem confusing at times, it is also a great benefit for photographers. It means we can choose from a selection of superb cameras with truly outstanding features—those superlatives are not exaggerations in today's market, either.

While some models are still quite expensive, digital cameras are now available in a wide range of prices, sizes, and configurations. That's what makes it difficult for any one person or publication to make specific recommendations as to which one is best. Best for whom? In what situation? Let's look at digital camera features to help you make sense of the choices available.

While cost is still a major consideration (digital cameras and their memory cards can be pricey) realize that you are not buying film and processing the way you used to. One thing to keep in mind is that discount stores, as well as electronics and computer stores, rarely have top-of-the-line, well-trained employees who can give you completely reliable information about digital cameras. In fact, in many cases, you can expect misleading—and sometimes just plain wrong—advice.

▷ FILM VS. DIGITAL CAPTURE

Which is better, film or digital? When will digital replace film? You've probably heard these questions being debated. They may give people who like to argue something to

Digital cameras have finally become viable, quality picture-taking tools.

do, but they distract the average photographer from looking at what is most important—getting better photos. Which will create better photos for you? That is going to depend on several variables.

The Benefits. Digital cameras do offer some benefits that film doesn't, including immediate access to your photos and the ability to review shots on an LCD monitor as soon as they are taken. Those things can be a huge benefit. You can find out immediately if your photos look good or not. You can then retake the ones that weren't successful while you are still with the subject. Plus, you can upload images to the web or print them out right away without waiting for processing.

The Sensor. The sensor of a digital camera is what captures the image. It is a light-sensitive electronic chip, called either a charge-coupled device (CCD) or a complementary metal oxide semiconductor (CMOS) sensor, which includes a certain number of pixels (tiny light-sensitive dots) that do the actual sensing. CCD sensors are more expensive but have been easier to produce with photo quality capabilities. Both offer excellent imaging capabilities.

More important to the sensor is the number of pixels (or area resolution). More pixels means more detail can be "sensed" or captured. This number is typically given in millions of pixels, or megapixels. A good rule of thumb is that two megapixels will give an excellent 5x7, three megapixels an 8x10, and five megapixels an 11x14. It is possible to make larger prints, but 35mm-equivalent quality is best seen at these sizes.

In addition, the electronic information that comes from the sensor is processed by the camera, resulting in

Digital cameras are superb choices for any type of photography. They are wonderful for portraits because you can review the shot on the LCD monitor to be sure your subject looks good.

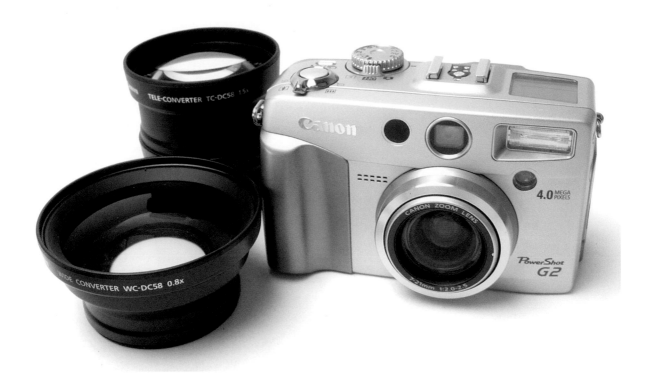

High-quality, full-featured compact digital cameras offer a whole range of possibilities, including add-on accessory lenses to extend the range of the attached zoom lens.

images that look different from different cameras, even if the sensor is the same. Which one is best is a very subjective question.

Very expensive, professional cameras often have sensors that don't seem all that different in megapixels captured. Yet, they are different. These sensors are often physically larger, meaning the pixels are bigger as well. This allows camera manufacturers to capture images with better color, tonality, and less "noise" in dark conditions (noise looks a little like grain in the shadows).

Camera Type. Digital cameras can be divided into a number of types based on their design and intended use, such as studio cameras, 35mm-style SLRs, prosumer models, advanced amateur cameras, and basic point & shoot models. Each has its advantages.

A simple, basic point & shoot digital camera.

A prosumer, full-featured digital camera.

Basic point & shoot cameras are low-priced and often very low in megabytes as well. They have limited zoom ranges for the lenses and are mostly automatic with few other controls. They can be a good start for understanding digital cameras, but most serious photographers will find them limiting. These cameras also tend to be small and compact.

Advanced amateur models jump up in cost, but for many photographers, that cost is well-justified. These cameras have better lenses (including faster speeds and bigger zooms), higher megapixel sensors, better metering and autofocus systems, many user-set controls from shutter speed to white balance (the ability of the camera to adapt to different colors of light), threaded lens fronts for filters and other accessories, and more. These cameras can do a lot for a photographer and vary quite a bit in size (which frequently depends on the lens).

Prosumer models appeal to both the advanced amateur and professional. These take the advanced camera type up a notch and typically offer total manual as well as auto-

matic control, dedicated accessory lenses, add-on flash capabilities, the best in metering and autofocus, and so on. In short, these cameras really perform in the hands of a skilled photographer. This camera type can be compact given all of its features, but is rarely one of the smallest.

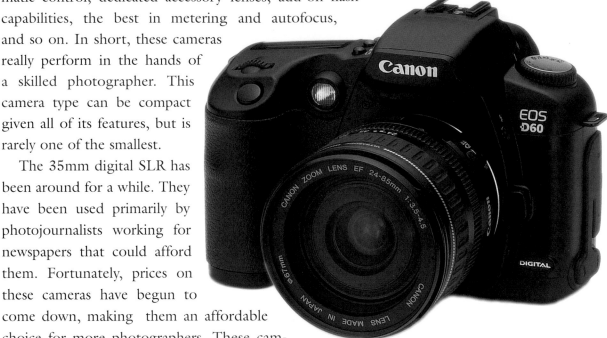

The 35mm digital SLR has been around for a while. They have been used primarily by photojournalists working for newspapers that could afford them. Fortunately, prices on these cameras have begun to come down, making them an affordable choice for more photographers. These cameras offer everything that prosumer models do in a body that looks like a 35mm camera and include interchangeable lens capability. Being able to use wide-angle to telephoto lenses is a big plus for this camera type.

An interchangeable lens digital SLR.

Studio cameras (and digital backs) offer tremendous quality in terms of sharpness, image size, tonal range and

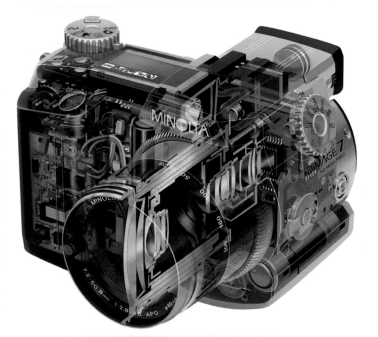

A fixed-zoom-lens digital SLR and its insides.

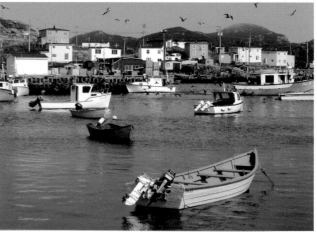

Digital cameras have the capabilities and quality for any type of photography you may be interested in.

so forth, but they also come with a very high price tag. They really are strictly for the pros that need them.

Viewfinder/Monitor. One thing that really sets nearly all digital cameras apart from film cameras is the multiple ways in which you can view your image. You usually get a regular viewfinder (often optical like a traditional camera) and an LCD monitor. The LCD monitor on the back of the camera lets you see what the camera lens is seeing. It also allows you to review your shots as you go.

The back of a digital camera offers features never found on film cameras. The LCD monitor is key both to help you better see your subject and to access important controls.

A swiveling, tilting LCD monitor makes a digital camera even more versatile by allowing you to raise the camera over your head or lower it to the ground and still see what the camera is seeing.

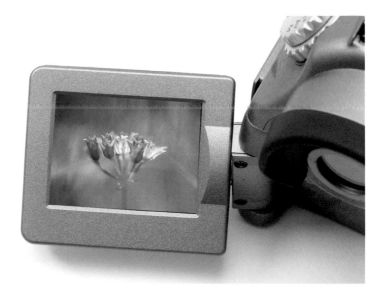

Optical viewfinders allow you to frame up your subject without using battery power. Some viewfinders now use a tiny LCD screen inside the camera for a direct look at what your lens is seeing. Such LCDs are brighter and easier to see than the monitor on the back of the camera because they are protected from bright light. However, they do add to the battery drain and often don't have the sharpness or detail of an optical viewfinder.

The back-mounted LCD will generally be about two inches across, but this will vary depending on the size of the camera. They can be hard to see in bright light, but camera manufacturers have been trying to make the units brighter (so they show up better even when in sun). The LCD is such a great feature—it is like having a Polaroid, only it's faster and does not create waste. You can review your shots here, even magnifying them to be sure a detail is sharp. You can usually check your shot before taking the exposure in the LCD monitor to ensure that you are getting exactly what you need. This can also help you better frame close-ups.

Lens. When digital cameras first came out, their resolution was so low that as long as the lens was more or less in focus, little else mattered. With modern multi-megapixel cameras, this has changed. The camera sensor can see the difference in lenses and that can be translated to your prints. Better lenses typically come from the cam-

The zoom lens on a digital camera allows different perspectives on a subject. The top image is at the wide-angle setting, the bottom is at the telephoto setting.

era manufacturers, and when the same focal lengths are compared, such lenses are typically bigger than those on low-priced cameras.

When looking at a digital camera, check the lens' focal length and maximum f-stop. Focal length should be available, somewhere, in 35mm equivalents (you may have to check the manual). You'll find the actual focal length to have very low numbers, such as 7–21 mm. The camera sensor is small and makes the lens act like a telephoto, giving this 7–21mm example, perhaps, an equivalent range of 38–116mm (the exact equivalence will depend on the sensor size).

Although some 35mm-style digital SLRs are becoming available with full-frame sensors (meaning the focal length of a lens acts like its focal length because the sen-

sor is the same size as 35mm film), these are still very expensive. Most 35mm-type cameras have a sensor that will require you to multiply your focal lengths by some factor, such as 1.5x, to get an equivalent.

Most consumer digital cameras come with zoom lenses offering maximum f-stops in the f/3.5 and higher range (making them fairly slow, meaning they let in less light). A few have fast lenses down around f/2. The advantage to the latter is better low-light photos and the ability to gain more control over depth of field.

Most digital cameras have a fixed zoom lens. They usually have trouble getting a very wide-angle view, and do much better at the telephoto range (this has to do with the way the sensor and lens interact). Most are in the 3X range, giving approximately 38–116mm in traditional 35mm terms. Digital zoom is not a true zoom. In simple

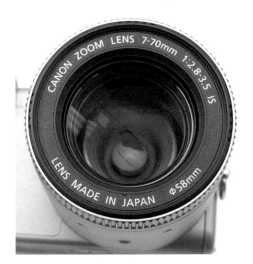

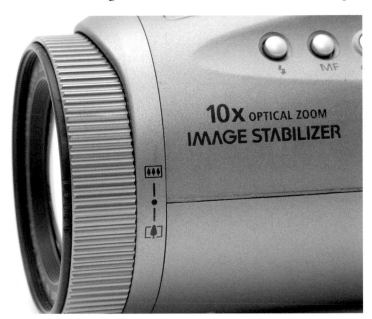

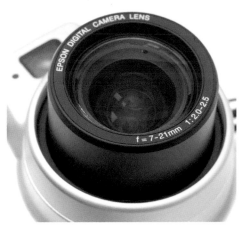

The optical (not digital) zoom is very important to your camera's versatility and image quality. The focal length numbers will look different than what you are used to with 35mm as the sensor size is smaller than 35mm film.

terms, it takes the sensor and crops it electronically to give the equivalent of a zoom. The result is fewer pixels to capture your image and a distinct drop in image quality.

If you need the extra focal length power, consider buying accessory lenses that screw into the camera in front of the existing lens. You can gain a better wide-angle point of view as well as more of a telephoto point of view for distant subjects. They are definitely worth the cost for the photographer who wants the most out of his or her digital camera.

▷ AUTO VS. MANUAL CONTROLS

You'll find various levels of control for digital cameras on the market. At the first level, everything is automatically controlled by the camera, and the photographer can change little. The highest level of camera offers full auto and manual controls for everything. The total automatic camera is fine for family members who don't photograph much or for that casual-shooting camera one uses at parties and on certain trips. Most photographers want at least some control over the picture. The ability to make the following adjustments can be very desirable: f-stop and shutter speed selection (and what choices you have for each), exposure compensation, white balance control and focus.

Advanced digital cameras offer a variety of controls from fully automatic to manual.

Flash. Nearly every digital camera comes with a built-in flash. This can usually be set for *auto, off,* and *fill* (always on). These settings allow you to get natural looking shots indoors without flash (off) and permit you to brighten shadows with fill flash. The built-in flash is rarely very powerful, so any flash effect will have a limited range.

Some cameras come with flash shoes and PC-connectors for adding an accessory flash. If you do a lot of indoor photography or are used to using added flash, this is an important feature to look for.

Image Memory Cards. Digital cameras store their photos, for the most part, on removable memory cards. Unfortunately, manufacturers have skimped on these and tend to put very underpowered cards in the camera boxes. One of the first things you should always do is buy an additional memory card (or cards) to handle more

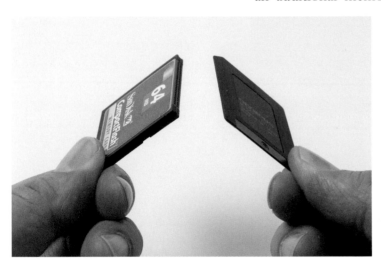

Two major types of camera memory cards include the sturdy Compact-Flash (left) and the simple Smart-Media (right) cards.

images. Making your image files small by using lower resolution and high compression will get lots of pictures on a small card, but image quality will suffer.

How much do you need? At least 32 MB would be a start for two- or three-megapixel cameras, while at least 64 MB is required for higher megapixel counts. More is better and will allow you to shoot longer without changing cards. Big cards are expensive, but then, you won't be paying for film and processing anymore, so in the long run, they are economical. Prices on these cards continue to drop as well.

Memory cards come in several types. The three most common are FlashCards®, SmartMedia®, and Memory Sticks®. In most cases, you will use whatever your camera uses as these types are not interchangeable among cameras. While each has its advantages and disadvantages, comparisons are an intellectual exercise not too useful for photographers. You should never choose a camera based on its memory card type.

Whatever you have, get a card reader for downloading images to your computer. This is the easiest and best way to get images from your camera into your computer. You simply take the card out of the camera, then insert it into the reader. Your computer will see the card as another drive.

Batteries. Digital cameras eat, devour, and burn up batteries. They have to have batteries in order to make everything work—plus that little monitor on the camera back really uses power. Standard alkalines will go in a hurry. The extra-duty alkalines designed for heavy power drain are better, but the best bet is rechargeables. Nickel-metal-hydride (NiMH) or lithium ion (li-on) rechargeables are great. They handle the power drain well, lasting as long as the extra-duty alkalines, but can be recharged, so you don't have to keep investing in batteries.

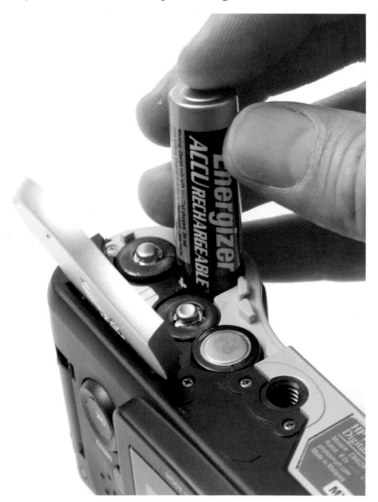

Digital cameras use up batteries quickly. Rechargeable NiMH batteries are an excellent choice. Always carry a spare set of charged batteries with you.

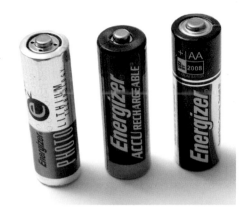

While rechargeable NiMH batteries (middle) are best, the lightweight lithium batteries (left) are an excellent choice for backup. They have up to five times the life of alkalines (right) but at only 2.5 times the price.

Here are a few battery management tips that will help you survive with a digital camera:

1. Turn your monitor off when you don't need it.

2. Turn the camera off whenever you are not photographing.

3. Have at least one extra set of rechargeable batteries so one can be charging while you shoot with the other. On trips, you will find three sets even better (one on the charger, one in the camera, one in the bag and ready to go when needed).

4. Use lithium batteries to back up rechargeables and whenever you need longer shooting time. These lightweight batteries offer five times the longevity of an alkaline and work better than any other battery in the cold. They also keep their power when not being used (rechargeables lose considerable energy as they sit).

▷ WHAT MAKES DIGITAL CAMERA IMAGES DIFFERENT?

Are digital cameras capable of taking photos that equal the quality achieved with film-based cameras? You'll hear good arguments on both sides of that question. The truth is, both film and digital are simply different means to capturing an image. No images captured on different films or media will be identical, and whether a particular image is "best" depends entirely on how the photo will be used. To get the most from a digital camera, it helps to understand the differences.

1. **Tonal Range Limitations.** Film has a better response to wide differences in tones (light to dark) in an image than the average consumer digital camera sensor. Dark areas in low light conditions have a tendency to pick up noise (a mottling or grain pattern) with a digital camera. In addition, bright areas do not blend

across the brightest tones as they do in film but have a tendency to "cut out" sharply so that overexposed elements can get a false edge that you won't see in film.

2. **ISO Change.** Digital cameras technically do not have an ISO rating, but they do get an ISO equivalent for their sensitivity. On many cameras, especially higher-end units, you can actually change ISO settings as you go. However, just like when you use faster film, there is a trade-off—higher speed settings will produce more noise, which looks like grain or static on a television, as well as slightly reduced color saturation. So, just like shooting slides or prints, reserve the faster speeds for situations when you really need them.

3. **Review as You Go.** Because any decent digital camera has an LCD monitor on it, you can review your shots as you go. As photographers, we frequently take multiple images—to adjust for exposure challenges, to look for new compositions and so forth. But we can't see any of them with a traditional camera until the film is developed. Some of the images are perfect, some marginal, and many surprise us for a number of reasons. With a digital camera, you can examine the shot right after taking it, while you are still at the location, and decide what needs to be done better. If there is an exposure problem, you know it right away. If the composition needs improvement, you can fix it while still standing in the key location.

4. **Edit as You Go.** One of the challenges of traditional photography is that as you shoot lots of film, you have to edit lots of film. With a digital camera, you can literally edit as you go. You erase images you don't like or need, you'll see gaps in your coverage while you are still in

Higher speed settings will produce more noise, which looks like grain or static on a television . . .

the field so you have a chance of fixing that, and you can file images in electronic folders.

5. **Free Experimentation.** The ability to both see a shot right after taking it and erase mistakes on the spot encourages most photographers to experiment and discover new possibilities for their photos. You can try a shot, look at it, try again right away, check the shot, then take new approaches to the subject. There is no penalty for failed shots—you just erase them! No one needs to know how well a particular shot went, and you can quickly forget any failed attempts.

6. **Archival Qualities.** Film lasts a long time compared to digital image files. Stored properly, modern slides and negatives will last many decades and more. Digital files can deteriorate in a few years if not stored on the right media. Most manufacturers will give magnetic media (such as a hard drive, a Zip disk, or a memory card) a life of under ten years (that is conservative, but some media will go faster). Optical media, such as CDs, will last much longer, possibly fifty to eighty years or more. Putting digital photos onto quality (not bargain) CD-Rs is a good idea. CD-RWs do not have the life of CD-Rs and should not be used for long-term storage of images.

7. **Size Limitations.** Digital cameras work with a certain amount of data available as area resolution. The size at which the image can be used depends on the size of the digital file. With film, you can make a print fairly large if you have the right enlarging tools. You are mainly limited by the lens sharpness and grain in the film. With a digital camera, you are limited first by the number of pixels of the sensor.

8. **No Filters?** In film, you have to filter for conditions where the film's color balance does not

Putting digital photos onto quality (not bargain) CD-Rs is a good idea.

match the scene. The best example of this for outdoor shooters is shade conditions. Without a filter, this situation often results in unnaturally blue images. With a digital camera's white balance controls, you can actually adjust the camera's response to the color biases of a scene.

9. **What Is a Sunrise or Sunset?** What color is a sunrise or sunset? What we see? What we think we see? We have grown accustomed to sunsets photographed with daylight-balanced film. So we expect photographs of sunsets to be actually much warmer than they really were (especially when shooting with the high-color films). A digital camera does not know what a sunset should look like. The white balance control will see the light and want to make it more

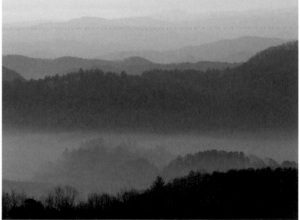
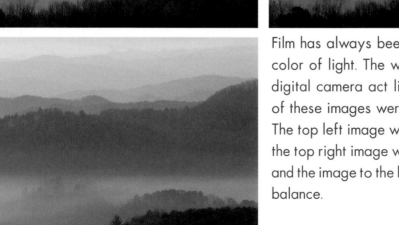

Film has always been strongly affected by the color of light. The white balance settings of a digital camera act like different film types. All of these images were shot at the same sunrise. The top left image was set to daylight balance, the top right image was set to indoor (tungsten), and the image to the left was on automatic white balance.

neutral so white looks closer to a pure white. The result is a sunset with less warmth than we expect from a photograph. The correction to this is to adjust the white balance before taking the shot—set it to the daylight preset.

10. **Creative Color Balance.** Many photographers have long used different films to achieve different effects, including shooting daylight-balanced film at sunset (common) and tungsten-balanced film in daylight (to add a cold cast). Filters have been used to add warmth to a scene, including intensifying certain colors. You can set the white balance of a digital camera to do some of these things without any extras—use tungsten settings for colder looks, use a cloudy day setting for a warmer sunlit scene, or try a fluorescent setting for stronger color. If the camera has a custom white balance setting (and many do), you can try balancing it by pointing the camera at something light blue (which will warm the scene because the camera will take out the blue to make it white), a light yellow (will cool the image), a light green (will add red to the photo), or other colors for special effects.

Use a cloudy day setting for a warmer sunlit scene.

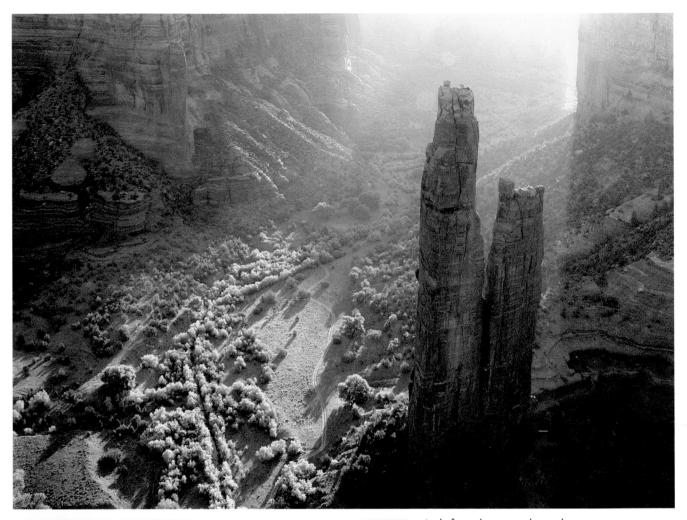

At left is the raw digital camera shot. It has captured the basic information. In the computer, the image comes alive by "developing" the color and detail in an image processing program.

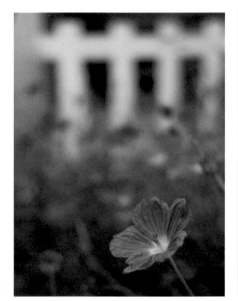 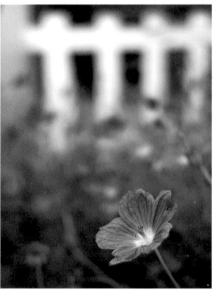 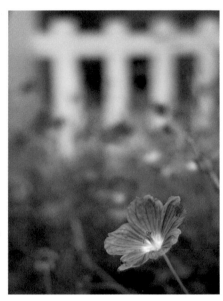

Digital imaging is definitely a craft that you master with practice. At left is the basic shot made by a digital camera. A simple adjustment to brighten the flower (middle) also makes the fence in the back too bright. A little more work (using selections in an image processing program to isolate the bottom and top parts of the photo) brings both into balance.

▶ 3

SCANNING

Scanning brings together traditional film camera techniques with digital. It allows you to capture image data from your slides, negatives, and prints to be used in the computer to enhance images, archive old photos, and just make really good prints.

Scanning is the best way for the price to get high-resolution, high-quality digital image files. You can get extremely good photos from digital cameras, but to match a standard film camera and scanner combination for features and prices, you'd spend a great deal more for the digital camera. You can buy an entry-level 35mm SLR with zoom lens and a good scanner combined for $1000 or less. This won't be top of the line, but you can get excellent results from the combination. You will be able to create images that combine resolution, color range, and tonality in ways that no digital camera for less than $5,000 can match.

This does not mean film is automatically better than digital capture. They are different. Certainly, there is a great deal of overlap where both methods are used, but still, they are separate but parallel ways of using the media. As digital capture gets better and less expensive, there may be less of a difference. But for now, scanning film is a great way of working with photography in the computer.

For now, scanning film is a great way of working with photography in the computer.

▷ SCANNING IS A CRAFT

Perhaps because people have gotten so used to going to a mini-lab and getting back good prints with little effort, photographers sometimes expect scanning to be just as

easy: Good photo goes into good scanner, therefore good scan comes out. This is not necessarily the case.

Scanning is truly a craft, meaning that it takes some practice and has many nuances in its application that can affect the final image. Still, modern scanners are largely designed to be easily used by the average photographer. You can get very good scans of most photos right away.

Because scanning is a craft, your scans will improve with practice. You will learn what photos will scan easily and which ones won't. With experience, you'll be able to predict how a particular image will look once scanned by your scanner.

▷ FLATBED OR FILM SCANNER

You have two basic choices for scanners—flatbed or film scanners (the latter is also known as a slide scanner, although that name is misleading as all film scanners do a great job with negatives as well). They both have advantages and disadvantages to such a degree that many photographers get one of each.

Flatbeds have become the standard, easy-to-use, inexpensive scanner. They generally offer a lot for very affordable prices. Flatbeds are designed to scan photographic prints and other flat, opaque artwork very well. You can

Flatbed scanners come with a range of capabilities and offer a lot for their cost.

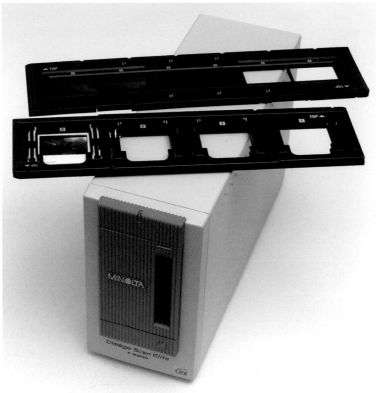

Film scanners allow you to capture maximum quality from color slides and negatives. They are not just "slide scanners" as they are sometimes called.

even use them to scan objects by placing the object directly on the scanning area (the glass). Direct scanning of film is possible with some flatbeds that come with adapters for scanning slides and negatives. However, there are limitations in how big you can make quality prints from such scans, especially with 35mm film, as the resolution of most flatbeds is not high enough to support prints larger than about 4x6. Also, of course, you are highly dependent on your film processing—to get the most out of a flatbed scan, you have to start with a high-quality print.

Film scanners used to be very expensive and hard to use. That is definitely not true today. They range quite a bit in price (although not as low as flatbeds), and even the top models are still cheaper than what you had to pay for any moderate quality scanner of a few years ago. Film scanners allow you to go to the original image as captured by your lens and camera at the film plane. This gets you to the maximum sharpness, tonal range, and color possible from that photo.

Some film scanners offer special features such as multiple sample scanning, Digital ICE (an automatic defect correction) and APS film scanning.

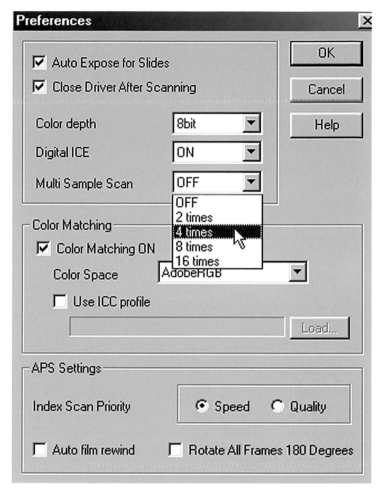

> ▷ **SCANNER FEATURES**

All scanners, whether flatbed or film, have certain features in common that influence what you can scan and the results. In addition, there are special features unique to each scanner type and manufacturer. Below is a discussion of the features you need to understand in order to choose and use a scanner well.

1. **Resolution.** Resolution is one of those hot marketing items that is often displayed prominently on scanner boxes. It is a very important feature for a scanner, but won't give you the whole picture. With a flatbed, you can get good, low-priced scanners that deliver 1200 dots per inch (dpi). I wouldn't go lower. For a film scanner, don't consider anything under

2400 dpi (including flatbeds that can handle film). These resolutions will allow you to get at least an 8x10 print from a 4x6-inch original print or 35mm film, respectively. Higher resolutions will allow you to get bigger prints or crop into the original and still get a large print from it. Look for *optical* resolution and don't be influenced by claims of high "enhanced" or interpolated resolution.

2. **Density Range.** Resolution gets so much attention, that this extremely important feature is often overlooked. This refers to the way the scanner sees all of the tones in your original image. Higher density ranges give more detail from the blackest to whitest parts of the print or film, resulting in better tonality of your image. This is expressed in a number (Dmax) usually between 3.0 and 4.0. However, this is a logarithmic scale, so each tenth actually represents a factor of 2. Better scanners will have a density range, or Dmax, of 3.4 and up. Manufacturers frequently do not give density

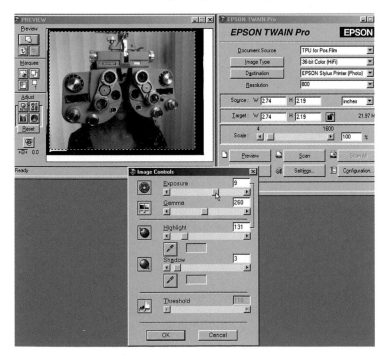

The scanner software is called a "driver," and it allows you to make corrections and adjustments to the image before scanning.

ranges for the lowest priced scanners (you can figure they are at the low end of the scale).

3. **Connectivity**. Scanners will connect to the computer in several ways. The most common today are either USB or SCSI. USB is very easy to set up, as you just plug the scanner into the USB port, install the software, and start scanning. Your computer does need a USB port. To use a SCSI connection, you need to have a SCSI board in your computer. If you don't have one already, it would have to be installed. The advantage is speed.

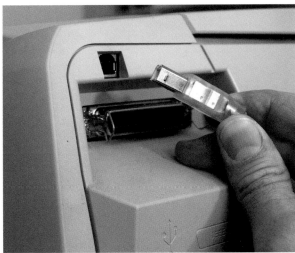

Two common connections for scanners include SCSI (left) and the ubiquitous USB (on a printer, right).

4. **Color Depth.** This used to be a more important issue when color depth was low. Most scanners today have 10- or 12-bit (or 30/36-bit—this is the same number, just expressed over the three computer colors, RGB) or higher color depth, which will do a great job. Higher color depth does mean more subtle colors and tones can be captured more easily.

5. **Speed.** Scanning speed may or may not be a critical issue for you. It depends on how many photos you need to scan and how often you do this. You definitely pay for speed in a scanner—the best speeds typically come from the most expensive models. Also, speed is influenced by

the resolution, connectivity, and your computer itself.

6. **One-Touch Scanning.** Many flatbeds, especially the lower-priced models, have one-touch scanning capabilities. This means you put the photo in the scanner and press one button to start a particular process. The scanner communicates to the computer to load the scanner software (called the driver) and begins scanning. One-touch scanning is usually set up with multiple, dedicated function buttons that you use for specific tasks.

7. **Defect Management.** Several film scanners include special features (such as Digital ICE™, ROC™ and GEM™) to recognize and correct for image defects such as dust and scratches, faded color, and high levels of grain. These can be real work savers.

8. **Transparency Adapters.** Many flatbeds offer a transparency adapter (for both slides and negatives), either built into the scanner body itself or as an added accessory. These can be great for medium and large format film, but are of limited value for 35mm unless the scanner resolution is at least 2400 dpi.

Some flatbeds offer one-touch scanning where a button on the scanner starts the task directly.

▷ PRICE

What you pay for a scanner is influenced by a number of things. Of course, how it is put together and the materials used will affect the cost. In addition, you will pay more as resolution increases, density range goes higher, color depth improves, and defect management tools are added to the scanner. In addition, a big factor can be speed. Many of the low-priced scanners are very, very slow. This may or may not be important to you, but speed is definitely a part of price. Also, a scanner's connectivity will affect price, with parallel port connections the cheapest (and slowest), USB often a little more but faster and easy to connect and SCSI the fastest of the common connections so far but harder to use. FireWire® (or IEEE 1394) is starting to show up as a way of connecting scanners to a FireWire-enabled computer, and this is superfast, but adds to the price.

▷ GETTING A GOOD SCAN

A good scan is a digital file that gives you what you need to make a good print. Scanning is a craft. It does take some trial and error to get the most from your scanner. Practice does make, if not perfect, much better digital image files. Here are some tips:

Care in placing your photo for scanning means less work later.

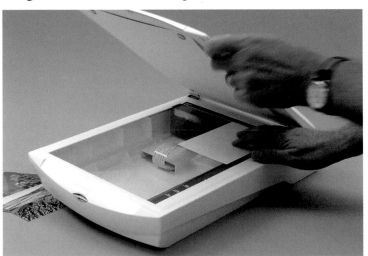

1. Start the scanning process by placing your image in the right orientation on your flatbed or in your film scanner. Open up your scanner

driver/software. Be sure the scan type matches your photo, e.g., slide, negative, type of print, etc.

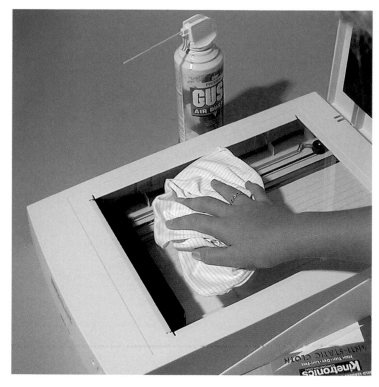

Keep your scanning area clean with compressed air and special cleaning cloths made for the purpose.

2. The key to getting a good scan from a print is to start with a good print. Clean the glass surface where the photo will go with an antistatic brush, compressed air, or special microfiber cleaning cloth as needed. Line up your print carefully. A crooked print will mean added work for you once it is in the computer.

3. Scanning from a slide has a great advantage of giving you an original to match. You need to pay close attention to exposure when you shoot the original scene. Beware of too dark a slide. Scanners, especially less expensive ones, can pick up noise (a pattern that is not in the image) in black and very dark areas. Use an antistatic brush and compressed air to clean the slide.

A blast of compressed air on slides and negatives before scanning will keep them clean for scanning and give you less work later fixing dust spots.

4. Scanning a negative directly offers one of the highest quality, most adaptable image files possible. Negatives can be hard to understand. Try to find a processor that gives you back prints with numbers on the back so you can find the exact negative you want. Clean your negative before putting it in the scanner. Use an antistatic brush and compressed air.

Use a film processing lab that gives you negative numbers on the back of your prints. That will help you find the right negative for scanning.

5. As long as it fits on the flatbed glass, any object can be scanned to make a photograph. Clean the glass surface just as if you were going to scan a photograph. Place the object on the glass, with the surface you want to see in the scan facing down. Multiple objects, like a

grouping of flowers and leaves, can be scanned, allowing you to create an interesting composition right on your flatbed's glass. You can actually enlarge a small object quite a bit in the scan by using higher resolutions.

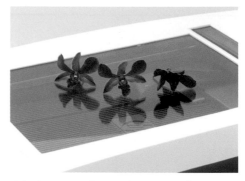

Almost anything that can fit on a scanner bed can be scanned.

6. Scan at a high enough resolution to give a big enough file to do what you want, yet don't scan too big or you will end up with a file that slows the computer down and clogs your hard drive. Rough guidelines for top-quality, photographic prints made on an inkjet printer, based on file size are: 4x6—4/5 MB, 5x7—7/10 MB, 8x10—14/20 MB.

7. Do a preview. Examine the preview carefully to see if it looks like you want it to look (this is a creative choice, so go by what you like).

8. Crop the scanning area to eliminate unneeded parts of your photo.

9. Check the highlights (bright areas) and shadows (dark areas) to see that detail is being captured. Correct what you can at this stage.

10. Correct color problems when you can.

Once you've made a preview scan (left), examine it carefully to decide what adjustments you need to make to it before doing the scan. In addition, you need to choose your scanning resolution carefully (right).

Most scanners let you make adjustments to the image before you make the final scan. Controls can be simple or advanced, but they all help you get the best scan possible going into your computer.

▷ UNDERSTANDING SCANNER ADJUSTMENTS

By making adjustments at the scan, you are telling the scanner how to look at the image so that it captures optimum detail from the image. If you have a good scan to begin with, you will have less work to do in your image processing software, plus adjustments there will often be easier as well. In addition, you will gain from the scanner's image-processing capabilities, which may be based on higher color depth than your program can work with.

Scanners come with a variety of controls, from brightness/contrast to color to rather sophisticated adjustments. Use what makes sense to you, then experiment. With practice, you will learn how they all work and what works best for you.

As mentioned earlier, the first thing you always want to do is crop your scanning area in the preview so that you are only scanning what you will need from the image. Getting rid of extraneous stuff will result in a smaller scan that will transfer faster to the computer, take up less space on the hard drive, and allow for faster processing in software.

Next, look at the brightness/contrast of your image. Sometimes you will find you have a difficult image because of problems in highlights or shadows. Adjust your preview image in order to capture problem detail good enough to make it work in your image processing

software. If you haven't captured that detail in the scan, no amount of later processing can bring it into your image.

Finally, check the color. You can often get rid of slight color casts at this point, such as a bluish tone from shooting in the shade or a greenish color from fluorescent lights. Photos will often look better when warmed up. This is especially true for people photos.

▶ SCANNING BY A LAB

Owning a scanner makes it easy and convenient to get images into your computer as you need them. However, you may want to consider having a lab do some scanning for you for several reasons:

1. You can get photos digitized without owning a scanner.

2. Very large, high-quality images are possible for when you need a really big print.

3. You don't have to baby-sit a scanner while capturing many images at once.

4. Medium and large format photos can be easily handled.

Many labs will do this scanning for you. You can get Photo CDs®, PictureCDs®, drum scans, and other scans put on a CD or Zip drive. It is important to realize that all of these are scans done by equipment operators/craftspeople. Some do a better job than others. If you find you get poor scans from one lab, that isn't necessarily the fault of the technology. You may have just hit a shop that doesn't know how to get the most from your photo.

Photo CDs are a proprietary format for photos developed by Kodak. They are available from many professional labs. A Photo CD comes with five resolutions, from a low-value thumbnail to one that makes a very good 8x10 to 11x14 print size. You can add up to 100 images on the CD, at once or in groups until it is full. The Pro Photo

> You can often get rid of slight color casts at this point . . .

CD® adds a sixth resolution, permitting very large prints, and allows medium and large format scans (the standard Photo CD is for 35mm only). Photo CD scanners have a density range of about 3.4.

PictureCDs are a way of getting images onto a CD at the time of processing. They use the standard JPEG file format for easy accessibility. The typical PictureCD is somewhat limited in file size (really only giving the best print at 5x7 or smaller), but a few labs offer higher resolutions.

Drum scans are a specialized scan that used to be the standard way images were digitized for printing in books and magazines. While still used for that purpose, desktop scanners and Photo CDs have cut this market quite a bit. However, a drum scan can give exceptional quality for individual scans at nearly any size needed.

Many photo labs are now offering scans from a variety of other sources. They tend to be as good as the operator doing the scan. I'd recommend doing a test before committing large numbers of scans to anyone.

A drum scan can give exceptional quality for individual scans . . .

▶ 4

DIGITAL MATH

▷ RESOLUTION

Resolution (dots per inch—dpi; pixels per inch—ppi) is one of the hardest parts to understand of the whole computer/photography relationship. At *PCPhoto* magazine, among the most common questions we get are those related to resolution. Many people want to avoid the issue all together. Yet, if you don't understand at least how the digital world deals with resolution, you will not be able to get the most from your images in the computer.

Resolution is how the pixels (the smallest part of an image file—picture-element or pix-el) of a photo are structured and defined for a particular image file or imaging device (an awkward term, but the only one to refer to the whole range of possibilities from cameras to scanner to printers). One of the toughest parts of resolution is that in the computer, it can change. The resolution of a lens or film never changes. It simply is. Yet, resolution dramatically changes as an image is used for the web, a letterhead, or a fine 16x20 print.

Resolution choices begin at the scan or digital camera shot, then continue until a print is made. Here's why they are so important:

1. **Getting Photos In**

 • **Scanners**—dpi affects image quality, what settings to use, speed of scanning, size of resulting file

 • **Digital Cameras**—pixel dimensions affect use, size image can be printed, detail rendition

Resolution choices begin at the scan or digital camera shot . . .

- **CDs**—pixel dimensions affect use, size of image, and detail rendition

2. Working Inside

- **File Size**—highly dependent on resolution

- **Storage**—high resolution means more storage needs

- **Processor**—higher resolutions require faster chips to keep processing times down

- **RAM**—high resolution requires more RAM

This is a folder of image files showing their sizes. The big files hold more detail and resolution and so allow larger prints. But they also take up more hard drive space.

3. Getting Photos Out

- **Printers**—require a specific area resolution for the size of the print

- **Monitor Display**—needs about 100 dpi at screen size

- **Web**—needs about 72–100 dpi at preferred size

▷ **PIXELS PER INCH VS. PIXELS PER IMAGE**

Forget the computer for a moment. Think about using mosaic tiles to make a portrait of someone. Each tile is

one solid color and brightness. Now if the tiles are very big, you can only get so many tiles into the space available for the picture. You can imagine that the big tiles will give a very blocky look to the portrait.

Now think about making that same portrait out of tiny tiles. You can get a lot of tiles into the same size picture. More tiles means you can gain some subtlety to the tonality, color, and details of the image. You will see less of the effects of the tiles, and more of the portrait will show through.

Now imagine creating that same portrait out of colored sand. The huge number of sand particles in that image area create the possibility of tremendous detail and color. From even a slight distance, the sand particles actually disappear from our vision, so that the portrait exists apart from the physical characteristics of the "medium."

Pixels are the basic building blocks of an image, just like the tiles or sand in the example. There can be a lot of them in an image or just a few. They can be spread out or compressed together. In an image of a given size, if there are very few pixels, the result will be similar to the big tiles of the first portrait described. In the same image, if there are many pixels, the result will be similar to the portrait created by the sand grains. The amount of image detail will be determined by the number of pixels.

These pixels can be grouped in different ways as well. Take the mosaic example with the small tiles. Depending on the grout used between the tiles, each tile may be closer or farther away from its neighbors. Spreading the tiles out will make a bigger image, bringing them close together will make the image smaller, yet both pictures will have the same total number of tiles. You could measure a foot of tiles and compare, for each picture, the number of tiles in that foot.

This is the tile equivalent of dots per inch (dpi)/pixels per inch (ppi). With pixels close together (a higher dpi), the image is smaller. As pixels are spread out (but the total number does not change), the image gets bigger.

The amount of image detail will be determined by the number of pixels.

Resolution affects image quality as related to the size of the image. The photo on the left shows the optimum resolution for this size "print." The shots in the center and on the right show what a photo looks like with too little resolution, one obviously way off, the other less so, but still a degradation from the correct resolution.

Note: The terms "dots per inch" and "pixels per inch" are used interchangeably—though some purists like to separate them. "Dpi" is the more common notation (though ppi is often used by software manufacturers), and will be used consistently in this text.

The thing to keep in mind is not that images get bigger or smaller, but that the image will change. Again, think of a mosaic. If you spread the tiles apart, you won't like the image if you view it close-up. At a distance it might be fine. In the digital world, this applies to how an image comes out of the computer. Different devices require different resolutions to make the best photo.

That might seem, then, that more pixels are better (consider the sand painting example). While that sounds good, in reality, you reach a point where adding extra pixels (or tile or sand) doesn't change your impression of the picture. After that, extra pixels are really extra, just stowaways that do little except slow down the computer, fill up storage space, and even cause crashes. You want to have enough resolution, but never more than you need.

▶ WHAT IS ENOUGH RESOLUTION?

The amount of resolution required depends entirely on what you want to do with your photo. It would be great if you could look up a specific number and just use it all the time. Unfortunately, you can't. Things like what type of printer you use can change the figures.

Logically, it would seem like the best thing to do is get the most resolution you can and go with that. Having high resolution is good as it gives you more options in working with an image. However, you do need to adjust it for different uses because in some cases, too high a resolution can cause problems, too.

The resolution of an inkjet printer (anywhere from 720–2800 dpi) is a number that tells you how ink is put down on the paper. The resolution of an image for printing (in the 240–300 range) is something entirely different and refers to how pixels are arranged in a data file. The printer is designed to handle an image file at 240–300 dpi then print it out from a printing head spraying ink on the paper at 720–2800 dpi. Image quality can actually decline if the image file is much above 300 dpi because the printer software doesn't know how you want to handle the extra pixels, so it throws out data.

You can often go lower in dpi with inkjets, depending on the paper used. For maximum quality on glossy papers, you need the 240–300 dpi (you will probably do fine with the lower number, but 300 dpi is a conservative figure that is always safe). For matte finishes, especially watercolor papers, you can drop down to 200 dpi and sometimes lower.

The amount of resolution required depends entirely on what you want to do with your photo.

If you are going to have your photos printed at a lab, check with them as to the required dpi of the image. The number can range quite a bit depending on their equipment.

If you want to display your photos on a computer monitor (such as in a digital slideshow), use 100 dpi at the size displayed (in terms of your photo on the monitor) as an easy, conservative number. For the web, the standard is 72 dpi.

Photo files can be output to any number of uses from slides and negatives, to wall-sized prints. For each, you need to know what the required dpi is—you'll have to check with the lab doing the work.

▷ RESOLUTION MATH

Okay, I've held off on this. Resolution math tends to intimidate a lot of people. Just the idea of doing "math" can be a little scary to creative folks. I know! You should see my checkbook! (Actually, you shouldn't or you might not believe I know anything about math.) If I can do this, so can you. If you understand a bit about resolution math, you will find your imaging decisions are a lot easier to make.

We've already talked about dpi (the number of pixels in an inch) and area resolution (the actual finite number of pixels that reside in the area). The two are very closely related. To find out an area resolution from dpi, you take the dimensions of the photo and multiply them by the dpi. You would do this to figure out how many pixels you might get from a photo being scanned.

For example, a 4x6-inch print scanned at 300 dpi is:
4 x 300 = 1200 *and*
6 x 300 = 1800

That gives a total area resolution of 1800x1200 (the larger number is commonly used first in the digital world). Now, say the same print were scanned at 600 dpi. The results would be 4 x 600 = 2400 and 6 x 600 = 3600

for a total of 3600x2400. Area resolution increases as the dpi increases for a given image size. For 35mm, the numbers are much changed because the image is so small. Scanning the 1x1.5-inch negative or slide at 2400 dpi would give:

$$1 \times 2400 = 2400 \; and$$
$$1.5 \times 2400 = 3600$$

Notice that the 600 dpi image from a 4x6 and the 2400 dpi image from a 1x1.5 (35mm) are identical in total pixels. The difference is in the density of the pixels.

Once you have a scanned image or you have a digital camera file, you will have a fixed pixel dimension. From that you can figure out how big the image can be used by dividing it by the desired dpi (as determined by the printer, service bureau, or whatever).

For example, an image with dimensions of 2400x3600 printed on an inkjet printer at 300 dpi would be 2400/300 = 8 and 3600/300 – 12. The result is an image that can be printed at 8x10 inches (8x12 actually). At 1200x1800, a photo printed on an inkjet would be: 1200/300 = 4 and 1800/300 = 6, so the image can be easily printed at 4x6 inches.

Once you have a scanned image or you have a digital camera file, you will have a fixed pixel dimension.

MAKING THE COMPUTER A DIGITAL DARKROOM

If a photo had bad color, poor contrast, or uneven tones, that was just too bad.

The darkroom was long a special place for photographers. It was there that they could take their black & white negatives (and this was the way most darkrooms worked, although color was possible) and turn them into beautiful prints in the warm light of the safelight. It was magical, including the way images appeared in the developer and in the control one had over the image.

But the popularity of the darkroom declined as color prints became popular and easy to get. Many people today have no idea of the possibilities that the darkroom offered. Because there is little to no direct control over a mini-lab print (and no control over a slide), an idea developed that somehow these images were "finished," that nothing could be done to them. If a photo had bad color, poor contrast, or uneven tones, that was just too bad. Sure, the color darkroom was possible, but printing color was hard to do, adjustments were not simple, color was hard to get right, and there were always all those toxic chemicals.

The computer totally changed this. We can do everything in the computer that a photographer used to do in the darkroom, but we don't have to be in a dark room or deal with smelly and toxic chemicals. The magic returns when the photographer discovers the wonderful control he or she gains over the image.

This new color (and black & white) darkroom offers a lot of possibilities—everything from correcting color and making contrast adjustments in order to get a great print, to wild fantasies that only exist in the image. What you do with the technology is up to you and your creative drive.

Don't let anyone tell you what you can or can't do here, although some people will try. The traditionalists will overemphasize the base image and will want to restrict what you can do with it. The wild creatives will overemphasize the changes that can be made to an image, sometimes ignoring what the original image was actually made for. Practice and see what works for you—ignore the rest.

▷ IMAGE PROCESSING SOFTWARE

A couple of years ago, photo imaging programs were proliferating like proverbial rabbits. That has changed considerably. In fact, some programs have disappeared completely. Now we see most of the action in newer and better versions of the surviving programs.

What is the best program for you? I don't know. I think it is presumptuous for anyone to say there is one program that absolutely is the best for everyone. A lot of people think they have to have Photoshop®—an outstanding program, but not at all for everyone. Photoshop can overwhelm and drown a neophyte in its complexity. I've seen people start to use Photoshop, then try a program like Picture It!® (which conventional wisdom says can't be any good since it is so cheap—wrong!) and discover it can do wonderful things for them. They forget about Photoshop.

Does that mean you should forget Photoshop and buy Picture It! software? Maybe, maybe not. Photoshop is definitely the premiere image-editing program today, and it offers tremendous tools for photographers who need it. On the other hand, if it doesn't suit your personal needs, it is a serious drain on your dollars and time (it takes a lot of time to master)—and you may find both are better spent elsewhere.

So we get to the good news and bad news about image-processing software: The good—there are a great variety of excellent choices available; The bad—there are a great variety of excellent choices available (meaning it can be hard to choose). We can go for the simplicity of an inexpensive, button-based program or we can opt for the

A couple of years ago, photo imaging programs were proliferating like proverbial rabbits.

high-buck, yet extremely powerful high-end, menu-based software.

Many photographers will find that having a couple of programs available will make the work easier, more convenient, and more fun. I would feel my computer was partially naked if I did not have at least two image processing programs available. Low-end programs often have some tools specifically designed for quick and easy control of anyone's image, plus they often have great templates for using your photos in cards, calendars, business pamphlets, and more—something you'll never find on a high-end program.

Most scanners and digital cameras, and many computers, now come with photo processing software as a part of the package. This is good in the sense that you get something to work with right away and you can get a feel for a type of software without any additional expense. But programs that come with equipment are often "light" versions of the software. These versions are often old editions of the software, or versions that have missing or disabled features. You may find it worth the money for an upgrade.

Selecting the best program for you isn't just a matter of comparing features. That can be very misleading since programs often handle those features differently. Plus, each program has its own unique personality, a personality that may or may not mesh with yours.

If you find something of interest, check your local computer store for the program. Examine the box to see how the manufacturer wants you to think about the software, along with features. This will give you a clue to its personality. Then check the company's web site. This is really important because you will get a feel for the program there, plus you'll see how they position the program. Do they seem to be talking to you and your needs? Is the list of features that they consider important also important to you?

Most companies offer a free download of a trial version from their web site. This is an excellent way of learning

Many photographers will find that having a couple of programs available will make the work easier . . .

how a program works, although all will have something of a learning curve, so a few minutes with a program may not be enough to tell you how it works for you.

One way of categorizing programs is to look at how most actions are initiated—either they are icon or button-based with lots of step-by-step elements or they are menu-based programs. The button-based, step-by-step programs are generally very accessible and usable right away. They are very strong on easy-to-use basic controls, special effects, and printing capabilities.

Menu-based programs offer more power with greater choices. Power and choices in the more advanced programs are a double-edged sword. On the one hand, they allow you to do some very advanced image processing. But they also mean more time dealing with a steep learning curve and having to navigate all the tools available by yourself, and rarely with helpful wizards or animated icons.

Lower-end programs tend to add a lot of templates. These give you predesigned forms that offer everything from greeting cards to calendars. If you feel your creative design abilities are not a strong point, templates might be perfect for you. Be sure the program offers designs that

Image processing software can be categorized as icon/button based (left) or menu-based (right).

you like (see the packaging and web site to get a feel for this) and the types of designs you need (whether business or home related templates, for example).

Higher-end programs were once the only ones to use Photoshop plug-ins. Photoshop plug ins are specialized programs that do unique things, such as special effects, within host processing software. A Photoshop plug-in is actually just a standard and does not need Photoshop itself. If you run across a plug-in you like but don't own Photoshop or another high-end program, you can still use the plug-in with quite a few programs. We've tried to mention which ones use these plug-ins below.

▷ SIZING AND CROPPING IMAGES

One of the first things to do with an image once you have opened it into your software is to size and crop it. You want to work on your image in whatever size you need it to be, but no larger. Large photos mean large files, which can slow down your computer and tie up your hard drive unnecessarily.

In the previous chapter, we discussed resolution in some detail. All image processing software includes some means of sizing and resizing your photos based on the resolution. Open up the sizing/resizing part of your software (I can't give specifics as this is different for all programs—if you have trouble, check Help). Three number sets are important—the dpi (software usually refers to it as ppi) of the image, the dimensions in inches at that dpi, and the area resolution (how many pixels wide by high).

Some programs make it easy by asking you for a final size—you fill in the blanks and the program does the math. Some give only pixels or percentages and you have to do some math. Here are some guidelines:

1. First, change the dpi so that you are at a resolution you need for your final use. For inkjet prints, this will be 240–300 dpi. When changing dpi, be sure you are only changing the arrangement of pixels (how many per inch)—

Large photos mean large files, which can slow down your computer . . .

be sure Resample or similar image altering choices are NOT checked. The image file size in megabytes should remain the same.

2. Check your dimensions. If you're close to your needed size, don't do anything else yet (do a final size check once you have completed everything you want to do with your image, including final cropping).

3. Adjust dimensions. If your photo needs to be reduced in size, change the dimensions to reflect the final size needed. Because a photo has a specific format, changing one side will change the other proportionately. At this point, you *do* want to check Resample. The file size should change and get smaller. Dpi should *not* change.

4. Resize up sparingly. You can enlarge an image from its basic size, but as your software does this, you can lose quality. Don't overdo this, as you can start to see problems at an increase of 25 percent. However, how much you can enlarge the image depends on the photo and your needs (digital camera files often enlarge better than scanned image files). You'll need to sharpen the photo due to some softness that will occur due to this enlargement. If you need to enlarge an image a lot, check out Genuine Fractals® software from LizardTech® (www.lizardtech.com).

Once sized, a photo should be cropped. This doesn't mean you have to have the very final crop at this point—you may find it can be tightened as you adjust other elements of the image. However, you do want to get rid of pixels you do not need. Excess pixels will only slow your computer's processor, clog your hard drive, and make you work with unimportant parts of the image.

Every program has a different cropping mode. All require you to select an area you want to keep (with a

selection or cropping tool), then you tell the computer to cut out this area and delete the rest of the image file.

▶ JUMPSTART YOUR IMAGE PROCESSING SOFTWARE

Regardless of the program you lean toward, there are some uniquely photographic ways of getting into the software's tools quickly and easily. Here are ten tips that will "jumpstart" you into mastering these programs for your digital darkroom needs:

1. Look at the photo. A lot of instruction on image processing programs is terribly confusing because it dwells on all the things a program can do rather than on what the photograph needs. Manufacturers love this approach because they think it helps sell software ("my software is better than theirs, which you can see from all the stuff we offer"). In truth, you actually know more than they do—even if you know nothing about an image processing program, you do know your photographs and what they need.

2. You don't have to know everything about a program to use the power of image processing. This is one thing you'll get from some Photoshop experts especially. They imply that you are stupid if you can't master all of the tools available. However, just consider Ansel Adams and other great darkroom workers. They did everything needed to bring the most out of their negatives with a very simple selection of tools. They could make the image lighter or darker, more or less contrasty, they could dodge to make a specific detail or area lighter, they could burn to make a particular part of the photo darker, plus a few other things that were variants of these controls.

You don't have to know everything about a program to use the power of image processing.

Yet with these "limited" darkroom controls, they did brilliant work. Somehow the mystique of Photoshop has encouraged people to think that they have to know every tool in an imaging program before they can use it. That just isn't true, and that attitude can keep you from accessing some very powerful possibilities that will help you make better photos.

3. Don't worry about the *right* way. I have heard this all too often—only certain ways of using a program are "right," or that you should never use certain tools. This rumor seems in part to be spread by people who would like to keep Photoshop "pure" and done "properly" (by any number of their standards). Forget them. If you try something in an image-processing program and it gives you the result you want, then you have done it the right way!

4. To start, focus on the part of the menu that has the brightness/contrast and color sections. Most photographers will go back to the brightness/contrast and color controls (there are several of each) again and again. If these controls (and the toolbar) were the only parts of the program available, you could still do a huge amount of work on images.

5. Do the "extreme" thing. Once you start trying out the controls, push them to extreme positions—way beyond where they should be in order to make a reasonable adjustment. This is the best way to see what a control will do. So often photographers try adjustments in little steps. They are afraid of hurting the photo. You can't! Just undo or reset if it isn't working the way you want it to.

Using the "extreme" way will also help if you forget what a certain tool does or you are using it for the first

> If these controls
>
> were the only parts
>
> of the program available,
>
> you could still do
>
> a huge amount of work
>
> on images.

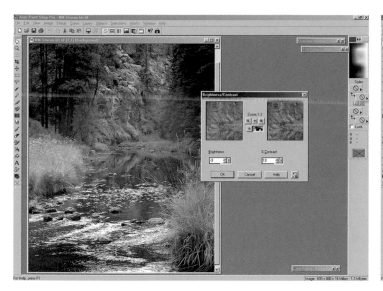

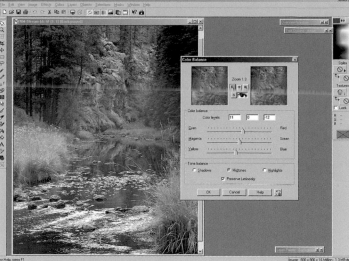

This page shows some highly photographic tools in an image processing software program. Left is brightness contrast, right shows color balance.

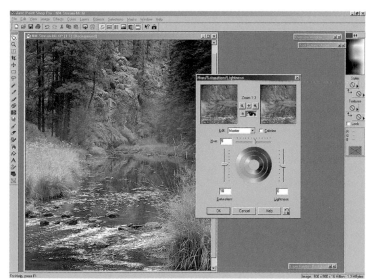

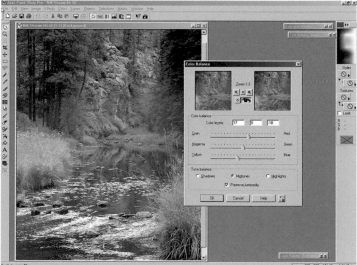

Left demonstrates hue and saturation being adjusted. At right is a "warming" filter created by using color balance to add red and yellow to the image.

time. Just try it and push it to an extreme. That will tell you if the control is appropriate for what you need to do, and it will point you in the right direction for its use.

When trying out adjustments, push them to extremes to see what they will do. Then bring the controls back to a normal setting. This will help you make better adjustments than if you try to make only very subtle changes at first.

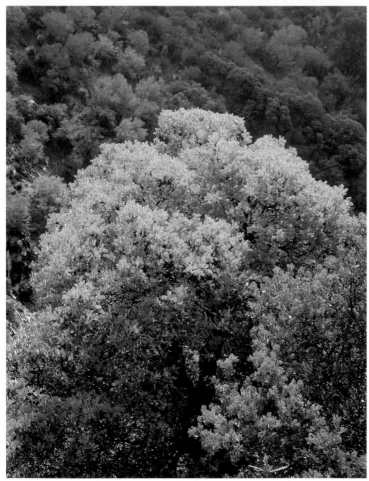

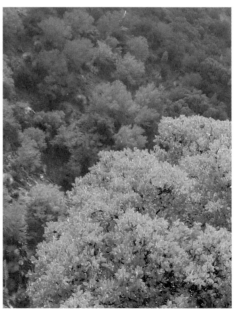

Contrast control has long been part of the black & white darkroom, but was difficult to affect in color work. Finally, photographers have that total control over the image whether it is black & white or color.

6. Brightness/contrast adjustments are basic dark-room controls. You know if a photo is too light or too dark, or if it is too contrasty or too flat. Your software will give you a number of tools that will make your photo look better by adjusting these parameters. There is even a control called "Brightness/Contrast." That particular control has some limitations, but it's so intuitive and so photographic that it's a great place for photographers to start.

"Levels" and "Curves" look intimidating, but they are simply ways of gaining control over brightness and contrast in more precise ways (including making an image brighter or darker with minimal change of highlights and shadows). They do require a little practice to understand, but can be worth the effort.

7. Color can be adjusted. The trend toward color through the '70s and '80s hastened the demise of the darkroom. Because color in slides could not be changed and color in prints was typically not adjusted by the photographer, a rather odd idea developed that color photos were "done" at exposure. The resulting image, in

Color can be adjusted in a number of ways in any image processing program. This is your chance to make your photos look the way you want them to.

other words, was final—whether the color was accurate or not. Image processing programs give us the great opportunity to adjust color to get rid of color casts, correct color problems, and make your image look better colorwise. Try out the "Color Balance" and "Hue/Saturation" tools to start.

8. Use selections to isolate effects. One of the secrets of Ansel Adams's darkroom work, as well as modern darkroom workers like Chris Ranier or John Sexton, is the way they work on small areas in an overall photograph. After making overall exposure and contrast changes, they go in and tweak this bright spot here, that dark section there, and so forth. You gain the same type of control to an even greater degree by selecting a specific area of your photo and isolating your effects to that selection—for example, you might select the sky so it can be adjusted separately from the ground. By making a selection, you can totally change whatever is inside the selected area (which can be quite precise) without any affect on adjacent pixels (something right next to the selected area, but outside the selection).

My web site (www.rsphotovideos.com) includes videotapes on how to work with image processing programs.

▷ POSSIBILITIES OF CONTROL 1: BRIGHTNESS AND CONTRAST

While modern autoexposure systems in cameras have made good exposures commonplace, photographs are still often the wrong brightness or contrast for your needs. Sometimes bad exposure is the culprit, but more often, you just find the photo will look or communicate better if it is lighter or darker.

Nearly all image processing software includes the basic brightness/contrast control or feature. This is a great

You might select the sky so it can be adjusted separately from the ground.

one, as mentioned above, for the photographer to start with. It is very intuitive. You generally push a control to the left to make the image darker, and to the right to make it lighter. Contrast is then adjusted to correct for any graying of the image. You almost always have to adjust both controls, which is why they usually come together.

Levels are an important brightness/contrast control for the photographer because they allow highlights and shadows to be adjusted separately. The key elements are the left (black) and right (white) triangles under the histogram (the graph).

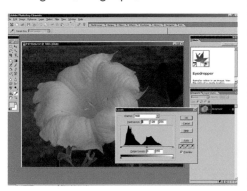

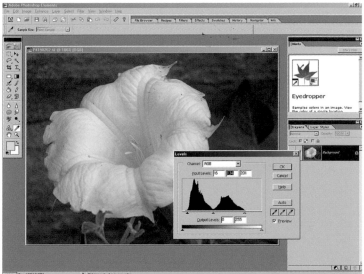

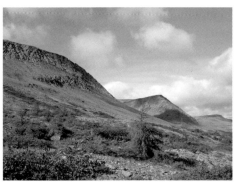

There was some wonderful detail and color waiting to be unearthed in the original shot in Gros Morne National Park in Newfoundland. Once you start working with images in the computer, you'll be able to recognize the potential of many scenes as you photograph them.

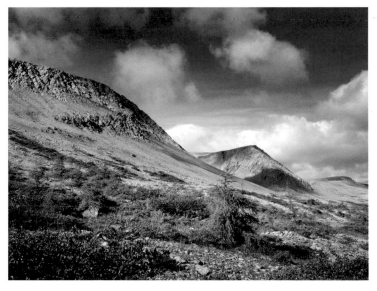

Many color images shot on cloudy days can benefit from an increase in contrast. Don't be afraid to make dark scenes look dark, even though the camera exposed them more brightly. In a similar vein, make bright scenes look bright, even if the camera made them dark. Never be

afraid to make some dramatic changes to your image if it needs it.

Brightness/Contrast is a good beginning tool, but you will quickly want to move on. The problem with this control is that it makes everything brighter or darker, and that may not be best for your image.

Levels is an excellent brightness/contrast tool, but it intimidates a lot of photographers because at first, all you see is a graph. You don't have to understand how to explain this graph or read all of its nuances. However, you can quickly understand the key points to using it.

The graph—or histogram, as it is called—represents how many pixels there are at given brightness values in your photo. The left side is black, the right side white. In most cases, you will always want a black and a white in your photo (that makes it look lively and crisp). This means that your pixels must start in black and end in white.

All you need to do is move the black marker (at the left) to the right so that it is under the start of the "mountains" of the histogram on the left. As you move it under the histogram, the photo will get darker, but mostly in the darkest parts of the photo. The brightest areas will stay bright. You can move it as far as you want, which will make the blacks start appearing in your photo in more and more of the dark areas. This will increase the photo's contrast.

Next, move the white marker (at the right) to the left so that it is under the start of the "mountains" of the histogram on its right. As you move the white marker under the histogram, the photo will get brighter, but mostly in the brightest parts of the photo. The shadow areas will stay dark. You can also move it as far as you want, which will make the whites start appearing in your photo in more and more of the brighter areas. This will again increase the photo's contrast.

You finish by adjusting the midtones (the middle marker). Move it right or left until the overall photo looks good. You can tweak and adjust all of these markers until

As you move the white marker under the histogram, the photo will get brighter . . .

you like what you see. This can help you get the most out of your image. Once the photo looks good, click Okay and the program will do the processing.

▶ Possibilities of Control 2: Color

Color films are good—almost too good. They record everything, even if the color of the light isn't quite right for your subject. While digital cameras' white balance controls are great, on automatic, they do make mistakes, so color can be off.

Color is not an absolute. It is highly influenced by a lot of things, from the color of light to the color of a subject's surroundings to emotional and psychological factors. But as a photographer, you know when the color of your photo is right or wrong. The computer gives us the chance to correct color problems and make color work for us, not against us.

There are several key software controls that can be used to adjust color. Some programs have automatic controls that can be helpful to remove a color cast. With them, you simply click on something that should be white or neutral gray and the program corrects the overall color of the image based on your choice. A tip for this tool is to try different things in the image, including colors that are not necessarily gray. For example, if you click on a light blue, you may find the image will warm up nicely (because the program is removing the cool blue). You will also get some weird and funky effects that may be fun or just odd.

Probably the easiest and most intuitive of color controls is color balance. This adjustment is usually based on the three computer colors, RGB (red-green-blue) and their opposites (cyan-magenta-yellow, CMY). You change the color balance of your photo by moving sliders toward or away from the RGB or CMY colors.

How you do this will vary depending on how you look at color in a photo. Some people look at their image and see that there is too much of a color in it, such as too much green or blue. They will then use the controls to

There are several key software controls that can be used to adjust color.

reduce that color. However, other people see the same photo in the opposite way. They see that a certain color is lacking, such as not enough magenta or yellow. They will then add that color with the software color balance controls. Neither way is better or worse—they are just different approaches.

Many photos benefit from a warming effect. To do this, add a little yellow and red to the photo (this is like using a warming filter on your lens). How much to add is very subjective. Try it. Compare the image with and without the effect (turn the preview on and off or apply the control then use undo and redo).

Levels, described above in the brightness/contrast section, can also be used to control color balance in many programs. You have to select a color channel to adjust: red, green, or blue. As you move the black, white, and midtone sliders on that channel, you are actually adjusting the amount of that color in those areas. Don't worry about which way to move the sliders—it is pretty obvious once you start because the color will change quickly. If you picked the wrong color channel or direction, just undo and try again.

Hue/Saturation is another important color adjustment for the photographer. These two controls usually come as a pair. Hue allows you to change the actual color of a color. While you can create extreme effects, most of the time, you will find it most useful to slightly tweak the color. This can be very helpful in dealing with strong color casts.

Saturation lets you change the richness or vibrancy of the color, e.g., how red a red is. This is an extremely beneficial tool. Digital camera images often have their color pulled down as compared to many films. Bumping the saturation up 10–15 percent can give these pictures a real boost. Cloudy days can also drop the color down, so again, a boost in saturation is worth trying. However, be careful that you don't go too far—the colors will look garish (unless you want that effect).

Don't worry about which way to move the sliders— it is pretty obvious once you start . . .

Color saturation in an image can be adjusted both as an overall change and by favoring specific colors.

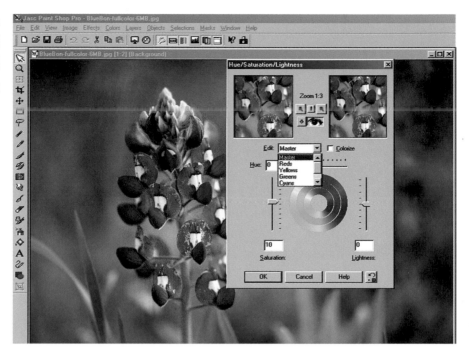

Consider reducing saturation in some cases. Sometimes, the colors captured on film, say on a very clear day, are too strong and overpower your subject. Lower the saturation 5–10 percent. You'll still have good color, but the harsh colors are dimmed.

▷ POSSIBILITIES OF CONTROL 3: SELECTIONS

You can do a lot with an image with just the overall Brightness/Contrast and Color Adjustment tools. Add one more key tool found in nearly all image processing software, Selections, and you gain a huge amount of control over your image. The great black & white photographers of the past, such as Ansel Adams or W. Eugene Smith, did all of their wonderful printing with basically just these types of controls—they made the image lighter or darker, changed its contrast, and adjusted specific areas of the photograph without changing other areas. The latter is just what selections let us do.

With selections, choose a part of the image that you are working on and outline that area with a special selection tool. Your ability to modify the image then changes. You can only adjust what is in the selected area. The rest of the photo is protected and cannot be affected by

As a photographer, you know if your photo looks right or not. Listen to your instincts and don't try to use all the tools in an image processing program. Use what works for you and ignore the rest until you need them.

any tool as long as there is a selection. You can do nearly anything you want to the selected area, but only to that location.

This offers tremendous control. If the area under a person's hat brim is too dark, you can select it and correct the tones without washing out the light areas (which would happen if the whole photo were brightened to bring out the detail under that brim). You can darken a sky without making the mountains too dark. And of course you can do much, much more.

Key Selection Tools. While you can certainly use whatever selection tools work for you, many photographers find the following selection tools especially helpful: the Magic Wand (click a spot and the computer figures out the selected area by looking for similar tones and colors), Polygon Lasso tool (also called point-to-point as it

draws a straight selection line every time you click the mouse button—you don't have to be an expert to follow a line with it, and curves can be done by moving short distances between clicks), and Magnetic or Smart Edge Lasso (this defines a selection area by automatically following a distinct edge as you move the cursor along it—works great with contrasty edges; use other tools for weak edges).

The way to learn how to make good selections is practice. This really is an eye–hand coordination thing that takes time to master. Some people prefer using the mouse for this, others a graphics tablet such as those made by Wacom®. Graphics tablets allow you to follow lines and edges with a pen-like device that is more intuitive for many people. However, it does need practice to master it. Some tips:

The way to learn

how to make

good selections

is practice.

1. Enlarge your image to the area you are selecting from. This way you can better see exactly where the selection edge needs to go.

2. When making selections, remember that you can always add or subtract from selections. You don't have to get the selection perfect the first time around. Add (+) and subtract (–) from the selection (shift is usually +, alt or option is –, but some programs have specific +/– buttons).

3. You can use multiple selection tools to adjust a selection. Use any that help. Don't feel you have to use whatever you started with.

4. If the area you want to select is against a simple background (for example, a person against the sky), try selecting the simple background first with the magic wand, then invert the selection to get your desired area.

5. Feather your selections. Feathering is a blending or smoothing of the selection edge. Photographs never have the sharp edges that a

computer is capable of, so some blending along the edge is needed. How much is totally dependent on the photo, so experiment.

▶ POSSIBILITIES OF CONTROL 4: CLONING

Our images don't always cooperate with us. Sometimes it seems gremlins must be getting dirt or scratches on our negatives, or worse, finding odd things to stick in our photos that have nothing to do with the subject, such as a branch coming out of the side of our friend's head.

The Cloning tool is a wonderful part of image processing. It lets us fix those little annoyances and make our subjects look their best, without unimportant distractions. The Cloning tool is actually a specialized selection and copying tool. It selects then copies little bits of image from one spot and deposits those bits onto another spot, effectively covering up problems.

There is a tendency among beginners to use cloning by setting a spot to clone from, then cloning over the new area in a continuous movement of the mouse. This is generally not the most effective way to clone and can make for a very clunky look to that part of the image.

Here are some cloning tips to make cloning work best for you:

1. Choose your brush size carefully. Use a size that is appropriate to both the defect you want to cover and the area surrounding it. More detail usually requires a smaller brush size.

2. Use a soft-edged brush. Hard edges will make your cloning look rough.

3. Clone in pieces or steps, not in a continuous movement. This will usually allow things to blend better.

4. Change your clone-from point. As you clone, change the spot you are cloning from. This will allow you to blend things more naturally.

Our images don't always cooperate with us.

5. Change your brush size. Sometimes one brush size will give you the basic cloning, but to finish off the area and make it blend, you may need to do some final clones with a different brush size.

6. Change the opacity. If your software allows you to change the cloning brush opacity, try reducing it (or increasing the transparency) if you are having trouble matching things in a clone and around the edge of the cloning area.

7. Watch for cloning patterns. Sometimes you just don't have enough clone-from space to work with and the cloned-over area starts showing a repeating pattern. One way of getting rid of that is to take a larger brush size, reduce the opacity, and try cloning from a different area into the repeating pattern.

▷ POSSIBILITIES OF CONTROL 5: LAYERS

Mention layers to many photographers just learning this digital business, and they break into a cold sweat. Layers do add a level of complexity to image processing, but they can also add whole new possibilities of control.

There's no question layers give us a degree of control beyond what we've had before. That's why many of the more advanced software programs include layers. They truly keep parts of your picture isolated so you can control things separately.

To understand layers, think of them like a stack of photos. If you take a series of prints, each one slightly different, and put them one on top of another, you have something like a stack of layers. Look at them from above. You can only see the top photo.

If you cut something out of the top photo, you can see the next print. Cut something out of that in the exposed area and you can see down another layer of photos. All layer-based programs work the same, from the top down. The top layer always affects what is seen beneath it, the

To understand layers, think of them like a stack of photos.

next layer affects the third layer and so forth. If you do anything to a layer under a solid layer, you won't see the effect, as the topside layer is the more important one.

Adjustment Layers are an easy way to get into layers. These are essentially clear layers—nothing is in them, except instructions. They affect how you see what is below them. You can have the instructions make the lower layers appear darker, a different color, or many other effects. The lower layer isn't actually changed, just how you see it when you look through the adjustment layer.

The advantage of an adjustment layer is that you make your changes to a photo on a separate layer rather than on the image itself. This allows you to keep the photo unchanged, then go back and adjust and readjust as needed to match a particular requirement for the photo. Readjusting a photo that has already been changed can be

Working to get the most from your image is not a technical process of using specific software, but a craft of the photographer who works to understand what a program can do for his or her photos. It takes practice, but the results are worth it.

a problem, especially if the change is substantial. Since the original image is unchanged under an adjustment layer, a readjustment is relatively easy. In addition, multiple adjustment layers can be used for advanced work, yet all of them can be continually tweaked and readjusted, and you never affect the underlying, base image.

Duplicate Layers are another great way of learning to use layers. Imagine after making a print of one of your photographs, you continued on making more prints and stacked them on top of one another. That is like a stack of duplicate layers. This offers a great way of experimenting and trying different effects. You could, for example, on your stack of prints, color one blue, one red, add lettering to another and so forth. Because they are separate, each thing you do to one picture has no effect on the others, yet you can compare them quite easily.

Duplicate Layers work just like that. You can try out things on a couple of layers, keeping the bottom layer unaffected, then compare by just turning the layers on and off. Anything you don't like, you just throw out (you can usually delete layers individually).

However, one of the best ways to use Duplicate Layers is to adjust different layers for specific parts of a photo, then cut out the unneeded parts on each layer. A landscape photo example can explain this: Suppose you have three layers, one for the sky, one for the ground, and a backup bottom layer that will not be changed. The top layer is the sky and you darken it to make the sky look great. This makes the ground too dark. You then go to the lower ground layer and adjust it to make the ground look good in contrast and color. The sky will be washed out.

Back to the sky layer on top. As long as the layer is turned on, you will not be able to see the lower layers (remember that layers always go top to bottom). However, we can cut out the dark ground on this layer. You can do that with selections (feather the edge), the Eraser tool (use a soft-edged brush), or a layer mask if your program offers it (a more complex technique that

offers a lot of flexibility). This is just like putting a dark print over a light print then cutting off part of the top print so the lower print shows through.

In this case, you are cutting some of the sky layer out (the dark ground) to allow the lower, adjusted ground layer to show through. Since the top sky is still in place, it blocks the washed-out ground layer sky. The result is an image with good sky and ground, but each is in a separate and totally controllable layer.

Another effective technique with Duplicate Layers comes from taking two layers, putting a strong effect on the top, then blending in the unaffected layer from below. This can be demonstrated with a soft-focus effect. To do this, apply a strong Gaussian blur filter/effect to the top layer (any blur will work—however, this particular one is very controllable). Then change the opacity of that layer to allow the sharp layer below to show through. How much blur you use and how much you allow the lower layer to show through is a very subjective decision. It depends on the subject and your taste. But you will find it works great for people, flowers, and even landscapes.

Layer Files. One thing you will notice with layers is that the file sizes go up dramatically. This affects the actual computer processing as well as how you save your files.

Larger files put more stress on your computer, especially on its RAM. With layers, you will need a minimum of 128 MB of RAM—and more is better. A faster processor may help if you are working with big files to begin with or if you are applying filter effects, but RAM is the most critical issue. Without enough RAM, your processor will be sitting idle waiting for data to come off the hard drive (stored there because of no room in RAM). This back-and-forth transfer of data to and from the hard drive as the processor works also makes your computer more susceptible to crashes. Your best bet is to ensure that you have enough RAM.

You do need a big hard drive, too. Most new computers today have plenty of hard drive space. You need to have enough to store your photos, your programs, and

One thing you will notice with layers is that the file sizes go up dramatically.

still have at least 1 GB free at all times. Your image processing software uses that space as "thinking room."

With layers, you will be saving your files differently, too. You must save in the program's native file format in order to keep the layers. If you do, you can open the file later with the layers intact and work again on the layers. You can file to the ubiquitous TIFF or JPEG formats, but these will not support your program's layers, so the file will be flattened.

Other Layer Tools. There are lots and lots of things you can do once you understand layers. You have to try them out, experiment, and spend some time with your program in order to get the most from them. Here are a few things to think about and try as you go:

1. By combining selections with layers you gain great new controls. You can select something from one layer and copy it to another. This then gives you the chance to work on them separately, just as when you use selections directly on the photo, but since the selection is now totally separate on a new layer, you can do all sorts of things to it (or other layers) without affecting anything else.

2. As you work, consider giving each layer a distinct and appropriate name. This will make it easier for you to find and work on a particular layer.

3. Put the washed-out image (or a weak part of an image) on a new layer. Then if your program has layer modes, change the mode to multiply. This will intensify the washed-out image (sometimes quite dramatically).

4. Copy a dark image (or dark part of an image) to a new layer. Now change the layer modes to Screen. This will nicely bring out detail in the dark areas (assuming there is detail there), without making it overly gray.

Once you've spent some time mastering your image processing program, whole new possibilities for better photos open up. In this sequence of shots of a young Navajo girl, the smile looked more natural in the left photo but there was a harsh highlight on the girl's cheek. The cheek from the middle photo was copied and pasted onto the first to get rid of that defect, resulting in the finished photo at right.

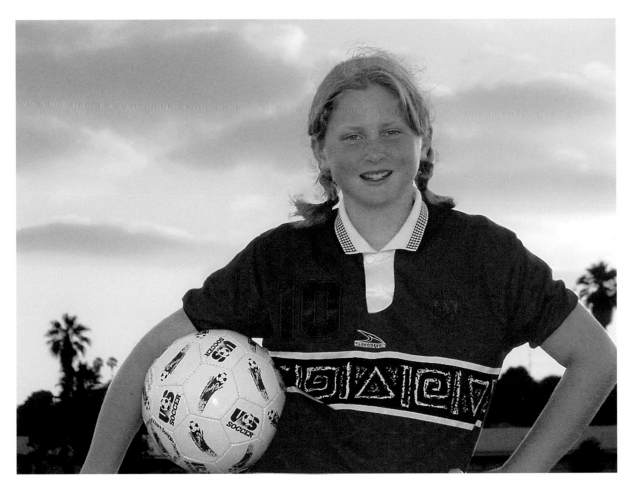

A great part of the digital darkroom is the ability you gain to adjust parts of an image separately. A weak flash was not enough to balance the soccer player against the sky. The girl was selected to isolate adjustments so she and the sky could be adjusted independently.

▶ POSSIBILITIES OF CONTROL 6:
SPECIALTY PROGRAMS AND PLUG-INS

As you've probably seen, there are some great effects possible with the computer. Yet, they sometimes require a lot of work or some lengthy experience with image processing software to be able to do them. Recognizing this, a number of enterprising manufacturers have produced special programs that simply do a few things well, rather than trying to compete with a full-fledged image-processing program. Some are stand-alone programs. Among the most useful include file browsers and printing applications.

Most photographers love image browsers like ACDSee® and CompuPic®. These allow you to quickly and easily see what your photos look like on your storage media (no matter if that is a hard drive or a Zip disk). They will show thumbnails of all photos in a folder at once, with their file names and other important information. This makes it easy to find a particular image. In addition, you can then print out the contents of a folder of images as an index print, varying the number per page and size of the photos as necessary. The resulting index print can be used as a hard-copy reference. These programs also have search functions and some limited database capabilities to help you find and sort your photos.

Printing programs allow you to make many combinations of prints on a single page of paper. They usually let you print out one photo many times on the page or multiple photos. You can also change the size of the images. This can really help you save paper and makes printing more convenient.

Plug-ins are also called Photoshop plug-ins or Photoshop-compatible plug-ins. They are small programs designed for very specific purposes that nest inside a larger image processing program. They are not just for Photoshop, however. The Photoshop name is used because they are designed to meet a standard based on Photoshop. Most mid- to high-range programs allow use of these plug-ins.

Most photographers love image browsers like ACDSee® and CompuPic®.

Some of the best of these plug-ins allow for photographic controls that aren't as readily apparent in the main programs. They include such things as a color-balancing and test printing utility (Vivid Details' Test Strip®), a set of controls that mimic on-camera filters such as split neutral density and polarizing filters (nik Multimedia nik Color Efex®), fancy edge treatments (Extensis Frames®), and more.

▷ FINISHING THE PHOTO

Once you have done everything you think is necessary to make your image look its best, you will always take some final steps, including refining your cropping, fixing any missed defects (like dust spots), and making sure your dpi is set correctly for future output.

A very important final step is sharpening. You can certainly sharpen a photo at any time during the whole process. However, most professionals sharpen at the end for a number of reasons, including the fact that the work you do on an image in brightness/contrast, color, etc., can affect the appearance of sharpness. Therefore, you don't want to try to adjust your image's sharpness to its best early on, as it can change.

Unsharp Mask. If your program has it (and many if not most do), Unsharp Mask is the best way to adjust sharpness. This not-intuitively named control gives you a set of three parameters for adjusting sharpness—a bit of complexity, perhaps, but also some wonderful control. They are: Amount, Radius, and Threshold (some software names them slightly differently, but they are usually all there).

Amount refers to the degree of sharpening effect actually applied. While photographers vary considerably in their preferences here, you'll find a setting somewhere between 100 and 200 to be a good place to start (some programs use a 0–100 scale—use the mid-range).

Radius is the distance in pixels the program will use in applying the unsharp mask. Unsharp Mask actually looks for slight differences in contrast for it to run its sharpen-

Most professionals sharpen at the end for a number of reasons . . .

ing effect. Radius controls how far it looks. You will generally set this between 1 and 2. Smaller photo files usually require less radius than large image files. If you have set this too high, you will get "ringing" around objects with strong contrast edges (ringing is a small white band, or ring, around the object). Plus, oversharpening just looks harsh and unnatural.

Threshold tells the software to look for a certain level in contrast in order to sharpen. At 0, even slight contrast is enhanced. In many pictures, this will be fine. However, with images that include a lot of photo defects (including JPEG artifacts) and grain, this can produce unwelcome sharpness of those defects and the grain. In that case, turn the threshold up to between 5 and 10. This will mellow the grain or defects and make them less noticeable. It will tone down the sharpening effect as well.

Edge Darkening Technique. Ansel Adams often wrote that a print was not complete until the edges were darkened. If you look at some of his photos, you will see some very strong edge effects. He did this because he felt it kept the eye concentrating on the image and not straying off at the edges. This can be done really easily with selections and adds a very nice finishing touch to any photo (if you compare the edge-darkened photo with the original, you will be amazed at the difference it makes).

You do this by making a big selection around most of the entire photo, just inside the outside edge (you can use the Circle, Rectangle, or Lasso selection tools). Put a very big feather on this (60–100 pixels), then invert the selection. The result is that you have selected all the edges of the photo.

Now darken this selected area (which is all the edges) with the Brightness/Contrast control. The amount is up to you, but can be any amount that looks good as long as it doesn't look too obvious. A variation of this technique is to copy the selected area and paste it to a new layer. Then you simply adjust that layer to the proper amount.

Dodging and burning controls have long been key to darkroom work to allow a photographer to make a photograph communicate better. In this shot, the leaves around the man were dodged and he was burned in to make him stronger as the focal point for the image (he was actually selected to help isolate these adjustments). Overall color and contrast were also adjusted.

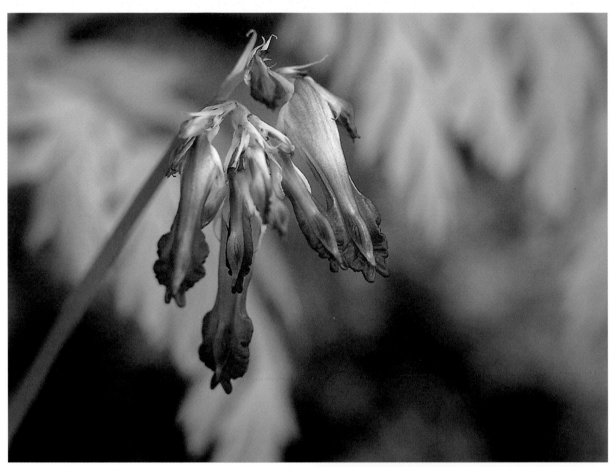

As photographers, we now have the ability to make photos reflect our impressions of the subject. We do not have to be restricted by the limitations of image capture technology, be that a film or digital camera sensor.

▶ 6

PRINTS AND MORE

Photographers have long wanted good prints of their images. We have also used our photos in other ways— slide shows, for example, were once a tradition of anyone who took a trip. And the ubiquitous 4x6 print became so common that many photographers lost sight of other possibilities. The computer now gives us new ways of making great prints, as well as slide shows, in new incarnations.

Getting a good print has long been a critical challenge for photographers. Darkroom workers would spend hours, even days, trying to make that perfect print. Even the casual photographer would often make repeated visits to the photo lab trying to get a decent print. Sometimes that even meant going to multiple labs.

Creating a good print can still be a challenge, but the computer and today's printers offer every photographer the chance to get absolutely stunning images. Making a great print is partly science and technology (the equipment), but it is also a craft. With practice and attention to detail, you will steadily make better prints. And you'll quickly find you can make prints with more detail and color than you ever got from an inexpensive machine print from a local processor.

Getting a good print has long been a critical challenge for photographers.

▷ TYPES OF PRINTS

While the inkjet is the most popular and easiest type of print from a computer, you actually have many options. You can make the prints yourself with inkjet, dye-sub, and laser printers. You can have a lab or other service bureau make prints for you using inkjet, dye-sub, laser, tradition-

al photo papers, and more—in a whole range of sizes. In addition, you also have the chance to output your files to slides, negatives, and other non-print uses of your photos. Let's look at the differences among these choices:

Inkjet Printer. This is the ubiquitous, common printer that everyone has. It uses tiny dots of ink to make a photographic print. Today, nearly every inkjet printer can do photo-quality prints. They are easy to use and can provide outstanding images. They vary in durability, however. Some printers' prints are very sensitive to moisture damage. Many printers today offer inks that don't fade, making prints that last for years, yet others will fade in a few years.

Dye-sub Printer. This type used to be the common "pro" printer. It uses a technology that "sublimates" or creates dye clouds from solid color, then applies the color to the paper. Dye-sub printers are relatively fast, offer excellent permanence in their prints, and always give a very photographic print. Colors tend to be quite vibrant. Dye-sub printers vary from portable mini-printers to heavy-duty professional models. The biggest disadvantage is cost. Dye-sub printers are very expensive compared to inkjet.

Inkjet printers (above) are capable of superb photo prints that are as good as or even better than any print you get from a lab.

Dye-sub printers (left) use a photo print technology that gives continuous tone photo prints.

Laser Printer. Long a standard for the highest quality and fastest text printing, laser printers haven't offered the image quality of the low-priced inkjets. It takes a very expensive laser printer to offer the best in photo print quality. However, laser printers are very fast and many people use them for printing newsletters and similar projects.

Lab Inkjet. Many labs offer special inkjet-type prints that can be absolutely stunning. They are usually available

in several forms: big or large-format inkjets (big printers offering images usually a minimum of 24-inches wide) and Iris or "Giclée" prints (often done for fine-art prints, so they can be a bit more expensive). Check with the individual lab for their specific requirements for your digital image file.

Lab Prints on Traditional Paper. In the last few years, many labs have installed equipment that allows prints to be made on traditional photo paper. Names you will hear include Fuji Frontier®, Fujix Pictrography®, Lightjet®, Lambda®, and Chromira®. These give you a print that is identical to a traditional print in form, weight, etc., but with the added dimension of digital processing. As with lab inkjets, check with the individual lab for their specific requirements for your digital image file.

▷ OTHER TYPES OF OUTPUT

Regardless of how you made the original photo, once in the computer, you can make all sorts of things from it. Slides and negatives are very easy—most labs that offer digital services can give you back a 35mm slide or negative from your digital file. You will need to check with the lab as to their requirements for file size and resolution. Some labs will also offer larger format transparencies or negatives. For professional photographers, these services can be terrific. They can make duplicates of the photographer's original equal to or even better than the original itself!

There are many other options for your photos, limited perhaps only by an entrepreneur's imagination. You can have them put on mugs, mousepads, t-shirts—even on the top of a cake. Internet photo service companies often have the greatest range of possibilities, but you may even be surprised at all the things a local lab may offer.

▷ CHOOSING AN INKJET PRINTER

Most photographers are going to want an inkjet printer, even if they have other plans for their digital images. Today you have a tremendous choice in inkjet printers,

They can make duplicates of the original equal to or even better than the original itself!

ranging from basic models under $100 to advanced models many times that. The choices can be confusing. Frankly, those low-priced units can produce excellent photographic prints. So what do you look for in an inkjet and what do you pay for in a more expensive model?

Speeds of inkjet printers vary greatly. Manufacturers' numbers, unfortunately, are often hyped by giving high page-per-minute speeds that are actually for draft, non-photo-quality images, which is never used in photographic printing.

Speed. Inkjet printers can be very slow when printing a photo. This is one place where price really does affect the results. The least expensive inkjets can be very, very slow in printing full-page photos at the highest quality settings. Unfortunately, printer manufacturers have gotten into a convention of hyping a printer's speed by using a rather silly standard—draft mode. No one uses draft mode for photos. Plus, their "color" speed is for a text piece with a little color graphic in it—again, printed draft mode.

A low-priced inkjet can take as long as ten to fifteen minutes to produce an 8x10 color photo print at photo quality. Higher priced models can drop that time to one or two minutes. A few manufacturers will give the photo-quality printing speeds in the specs if you search for them.

Color. Inkjets come with four or six colors. The number of colors can affect final photographic results, but good photo color isn't that simple. Color is affected by the actual inks and how they are applied to the paper.

Some more expensive four-color printers use specialized photo technologies that bring out terrific colors in the final photo quality prints. However, the six-color printers do seem to do a better job with subtle, bright tones in a photograph.

Ink Dot Size. Ink is placed on the paper as very tiny ink droplets. The smallest droplets allow the inkjet to print the best color and detail possible. Less expensive printers generally have larger ink droplets.

Resolution. Now this is a tricky area filled with marketing hype. Inkjet resolution refers to how a printer lays down ink on the paper. While it is true that you do need a certain resolution to generate a full, photo-quality print, resolution is only part of the story. Once you get past a certain point (and this depends on the printer and the type of paper used), a higher resolution is a marketing gimmick and not much else. How a printer puts down its ink droplets is just as important as resolution.

Lower priced inkjets sometimes don't have resolution comparable to higher priced units and don't have the same overall image quality on the highest quality, glossy papers. However, as you compare printers from different manufacturers that are designated their highest quality photo printers, there is little arbitrary difference among them that can be seen from resolution.

Life of Image. If you need long life to your prints, this is a very important issue. For a long time, inkjet printers made beautiful prints, but their life span was limited. Prints in the sun or under fluorescents would fade in as little as six months. Today, you have a choice. Low-priced, standard inkjet printers will give you a print with a life of two to five years in the light (less in bright sun). Some more expensive printers are the same if they use standard inkjet inks. The paper used can make a significant difference in print life, too, for all printers. Look for papers specifically labeled for a longer life.

In the past few years, some manufacturers have also developed long-lasting inkjet inks based on dyes (the traditional inkjet ink) and pigments. These offer print lives

Lower priced inkjets sometimes don't have resolution comparable to higher priced units . . .

of approximately 14–200 years, depending on paper and ink used. The pigmented inks last the longest.

Quietness. Inkjet printers vary quite a bit in noise levels. Typically, the less expensive printers are noisier. The only way to tell how quiet a printer is for your purposes is to hear one as it prints.

Connectivity. Printers connect to the computer today in basically two ways: parallel port and USB. Parallel port units are less expensive. A parallel port is a slower connection than USB, so it is typically used with less expensive, slower printers. USB is both faster and easier to use—if your computer has USB connections, this is the way to go. In the future, a very fast connection method known as FireWire®, IEEE 1394 or iLink® (different names for the same product) may become more important as it is a very fast way of connecting to the computer.

Paper Path. The paper goes through a printer in one of three ways—curved back on itself, straight-through with a slight bend and straight-through with no bend. Printers that have the paper in front curve it back on itself

With an inkjet printer, you have a tremendous range of print options, from image size to number of prints to the type of paper.

as the paper is pulled through the machine. The paper then exits the printing area just above the input tray. This allows a printer to be smaller from front to back and take up less depth on a desk. However, it also limits the paper that can be used—thicker papers can be a problem and might not even be picked up by the printer rollers at all.

Other printers bring the paper in from the back and give it a slight curve at the print head. This does mean you need more room from front to back on a desk for the printer, but you can also use more papers, including thicker ones. Some printers even have a special slot in the back of the unit to allow a straight-through passage of paper without any bend at all. These printers can often handle quite thick papers.

▶ How to Make Stunning Prints

Making a great print is not just a matter of buying the best printer. Every photo-quality printer out today is capable of producing a print as good as or better than

You can make excellent photo prints from inkjet printers if you pay attention to the file size, use the right paper, set your printer driver/software for photo quality and do some tests.

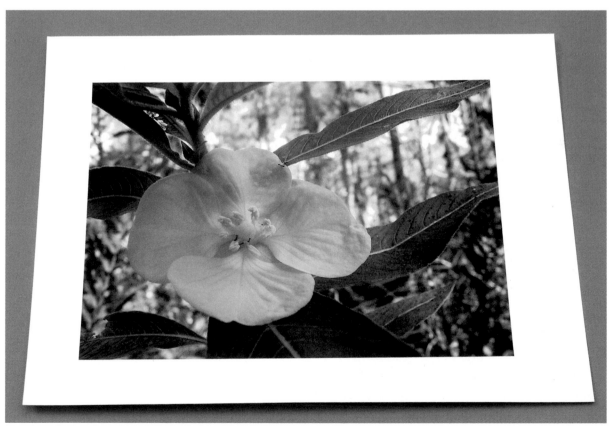

those available from your local mini-lab. However, the way that the printer is used affects the outcome of the final print. You must make a number of choices to get the best prints, and those choices include both subjective and experience-based options that lead to the craft of printmaking.

Here are some tips that can get your printmaking headed in the right direction:

1. Use the appropriate file size for the photo file. You must have enough data in the file to support the printer and the print size you are making. With less, print quality will fall off dramatically, including poor sharpness, graininess, increased pixelation, incomplete tonalities, and more. Depending on the printer and paper, you need about a 4–5 MB file for a 4x6-inch print, an 7–10 MB file for a 5x7 and a 14–20 MB file for an 8x10.

2. Use the right image file dpi. Your image should be at 240–300 dpi at the size printed. This means that whether the print is 4x6 or 8x10, for optimum quality, the dpi should be in that 240–300 range. It is important to remember that printer dpi has little to do with image file dpi. Both lower *and* higher dpi will result in reduced image quality.

3. Paper is an extremely critical element. You are always safe with the printer manufacturer's papers, but they can be limiting. You have to test other papers. Regardless of the brand, paper comes in many forms. You need to choose and use the best paper for your photo and its use.

4. Paper weight is important and this can be very subjective—is it heavy enough for what you need? Some of the sharpest, most beautiful prints come from the super-gloss "films."

Use the appropriate file size for the photo file.

These are very flimsy feeling, however—great for framing, but uncomfortable for handing around a group.

5. Look for a high whiteness value. Most papers will give a whiteness number (in the 90s is good), although not all do. The whiter the paper, the purer the colors and the better the overall tonal range of the print. This does not apply to some specialty papers (such as certain watercolor papers used for photo printing), as they may be purchased for their special tonality.

6. Choose an appropriate surface. Glossy papers give the best colors, sharpness, and tonal range, but not everyone likes their shine. Matte papers still offer excellent color, sharpness, and tonal range, and many photographers prefer their look, although they are definitely down from the glossy. Luster surfaces are in-between. You can also choose among many specialty papers, including canvas, silk, transparency, watercolor, and more for specific and unique printing effects. If you need to fold your paper (such as with a brochure or a greeting card), be sure your paper can fold without problems (for example, glossy papers often crack when folded).

7. Be sure the printer driver is set correctly. Many people don't even know you can set the printer. The default settings are rarely optimum for photos. The printer driver is a bit of software loaded when you install the printer on your computer. It then comes up whenever you decide to print. You have to select Properties or check for choices. You will be setting a paper choice, a quality/speed mode, orientation, and perhaps color adjustments. Usually when you choose a paper, the driver automatically chooses the best print quality/speed for

Glossy papers give the best colors, sharpness, and tonal range . . .

it. Experiment if you have a paper not on the list. Orientation will be Portrait (vertical) or Landscape (horizontal). If you have color management controls (such as ICM), use them. Other settings like Photo-enhance can also be useful.

8. Test, test, test. This was always the basis of making a good print in the darkroom—try something, experiment, find out what works. The hype of technology has convinced a lot of people that perfect prints are possible just from the technology. Yet, printing really is a craft, in part because it is so subjective. A good print for one person may be off-base for someone else. The craft of printing is mastered by printing out lots of prints; testing different papers,

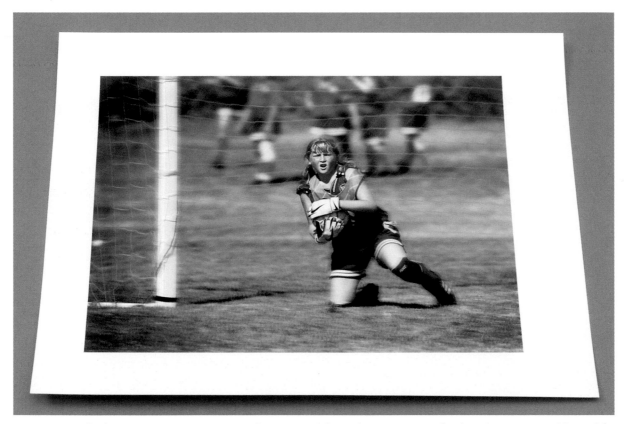

Longevity of inkjet prints is an issue. For long print life with any printer, find and use special long-life papers. For longest life, use printers with inks that are designed to be fade resistant for twenty years or more.

settings, etc., and then using those tests to refine the image.

9. Record changes needed for future printouts. Once you have figured out what adjustments are needed for a good print (brighter or darker settings than what looks good on the screen, different color adjustments, and so on), write them down. As long as you use the same printer and paper, these basic adjustments should not change.

10. Try software and hardware printing assists. Test Strip (Vivid Details) is an excellent piece of software (a "Photoshop" plug-in) that allows you to show multiple adjustments on an image then print all of them out on a single page. This can be a huge help. Monaco Systems offers simple color management software and hardware to calibrate your whole system for more consistent prints.

▶ DIGITAL SLIDE SHOWS

Slide shows long ranged from the tedious playback of every image shot on a lengthy trip to Europe by well-meaning relatives who believed everyone else wanted to see every shot to the slick, music-backed, image-dissolving shows of professionals and highly motivated amateurs.

The computer now gives us whole new ways of dealing with images as "slide shows." The easiest comes from special dedicated devices such as Microsoft's TV Photo Viewer, or a special Zip drive from Iomega called the FotoShow®. These units plugs directly into your TV and can be used without a computer. With the FotoShow, you simply plug in a memory card from a digital camera and the drive downloads the images to a Zip disk. Then you can sort and arrange images for a slide show by using your television screen. Playback is then on the TV, too, and can include music. You can also add or subtract images by connecting the unit to your computer (USB).

Once you have figured out what adjustments are needed for a good print, write them down.

Slide shows can be done on your computer directly, too. A number of programs are available that will allow you to sort and play photographs on the monitor, and to add music, captions, and special effects. You can work with any digital files, whether scanned from film or a digital camera photo. They may need to be resized for optimum use (size according to the screen resolution of your computer—if you are not sure of this, try making your horizontal images 1000 pixels wide, verticals 800 pixels tall).

Many people are familiar with Microsoft® PowerPoint® at work and find that using it for slide shows has a short learning curve. In addition, some slide-show software like FotoAngelo® from ACDSystems can be put onto a removable disk (such as CD-R) to transport to other computers. A lot of photographers are learning that they can quickly put together a slide show showcasing their latest trip or new baby and use it on their laptop wherever they go.

Digital projectors are rapidly dropping in price and will soon become an important way of showing off your slide shows. They are still expensive, but you can use them with your computer and video deck. They become an instant "large-screen TV" that will also project your slides. Very compact and bright units with excellent resolution are becoming common in the market.

Digital projectors let you project your digital images as beautiful slide shows (including music and narration). They also can act as a projection TV for the Super Bowl!

Another way of making a slide show is to use video software, then output the show to video tape. You do need to have a way of getting video out of your computer to do this—many video cards (a device that outputs the signal to your monitor) can be purchased with video in and out connections, too. A common video connection is the IEEE 1394/FireWire/iLink connection.

Easy-to-use video editing software works very well for making lively slide shows (with moving images, music and more) from your digital images. These images can be played back on the computer or on your TV (through tape, DVD or Video CD).

For slide shows, you only need to output video. You will bring your still photo files into the video program as photos (the program will convert them to video). Software like MGI VideoWave® or Ulead VideoStudio® are easy to use and offer a great deal of control over music, special effects (including moving the photo around the screen), and titles. Once you make your slide-video, you simply play it out to a video tape deck or camcorder to record it. Now you can play it anywhere someone has a deck and a TV.

▶ 7

ON THE WEB

The World Wide Web is a place filled with hype, yet it also can be a great location for using your photos. It definitely expands your possibilities. Attaching photos to e-mail alone can give a boost to your photography by getting it seen by friends and relatives across the country and around the world. E-mail and web sites can give professionals a good way of showing off images for prospective picture buyers. And much more is possible and will be possible in the future. The Internet is definitely a new world for photography.

▷ E-MAIL

E-mailing on the surface seems pretty simple: attach a picture file to an e-mail and send it off. Anyone who has tried this more than once knows that the reality tends to be a bit more complicated.

There are several key things you must think about when using photos with e-mail:

- picture size
- number of pictures
- your recipient's ability to receive photos

Picture Size. The Internet still poses some challenges for sending large amounts of data (which definitely applies to photo files as they are much larger than word processing files, for example). Sure, some people have connections with a large "bandwidth" (fast connection that lets large amounts of data go across it quickly), but most people don't. So a photo must be sized so that it

The World Wide Web is a place filled with hype, yet it also can be a great location for using your photos.

While each e-mail program is different, attaching a photo works largely the same. You click on an attachment icon (here, a paper clip) and a file window opens. You find the desired JPEG-compressed image, select it and it is attached to the e-mail. Keep photo files under 300 KB.

does not take too much time to send from your computer (upload) or be received at the location it is going to (download). Long upload or download times can be frustrating.

A good guideline is to keep photos to a file size of 200–300 kilobytes (KB) or less. This will load both directions in a reasonable time on nearly any computer. To get there, though, you need to compress the original image. While some recipients will just view an e-mail photo on-screen, many like to print it out. While an optimum printing file might be too big, you can often get away with a printing file of approximately 4x6 inches at 200 dpi for e-mail. This is then compressed moderately with JPEG compression by using a "Save As" command to get the size down to 200–300 KB.

Some image processing programs will give you a final file size in the JPEG dialogue box that comes up as you save. With others, you have to experiment, doing a save then checking your hard drive to see how big the file is. JPEG is a variable compression format (which means that file compression changes based on the detail in the image), so specific numbers cannot be given. More detailed images need more compression than photos with large areas of one tone or color to reach the same 200–300 KB range.

If a photo is to be sent to someone purely for on-screen viewing, you can go to a simple 640x480, 72 dpi, JPEG file. However, if the recipient is likely to print the image out, you need the bigger numbers.

Multiple Pictures. As you add photos onto a single e-mail, loading times will increase, plus you run a higher risk of image transmission problems. It is often a good idea to send photos in small groups of two or three at a time, maximum, with multiple e-mails.

Check with the Recipient. Because it isn't that hard to attach a photo to an e-mail, photographers sometimes do it without thinking about the recipient. You need to check to see if he or she is ready and able to receive photos (Will they know what to do with the photos? Where the files go on their hard drive when downloaded? How to open them?). Find out if they have file size restrictions or problems opening large e-mail files. Be sure your photo attachments stay small.

You may discover that your recipient has a good bandwidth and can handle larger image files. Find out how big. You may be able to send larger files (e.g., bigger photo sizes, less compression, or both) or more photos at a single time. Of course, you might also find out that e-mailed photos have caused your recipient major problems in the past. You may or may not be able to overcome this hurdle. You might try sending a small image file (under 100 KB) that is very carefully labeled (so it can be easily found on their hard drive) as a test and goodwill gesture. If you really run into resistance, don't fight it. Put your photos on a disk (such as a CD) and mail them.

> As you add photos onto a single e-mail, loading times will increase . . .

▶ WEB SITES AND MORE

Web sites are now easy enough to get and use that all sorts of people are employing them to display their photos—from birth announcement to small business sites. While sophisticated web site development and construction is beyond the scope of this book, there are many good books on the subject. What this book can offer is a brief overview of web sites and how to get your feet wet.

▷ PHOTO-SHARING/PHOTO-COMMUNITY SITES

One over-hyped aspect of the web has been the photo-sharing or photo-community sites. Early developers of these sites promised things that they could not deliver. Plus, they gave growth figures that had little to do with the reality of how people use the web and photography.

This area has had a major shakeout of businesses. Some have bought others, some have gone out of business, and some are still plugging away with their original concept. Yet, in spite of all this, these sites do offer some advantages to photographers. They allow photographs to be posted to a location unique to you, that you can control access to, and at very low cost.

Photo-sharing sites are one way of letting friends and relatives see your photos from a distance.

To participate, you simply go to the site, enroll in the community or other program, and upload your images to a password-protected place. You then give friends, relatives, buyers—whoever you want—the web-site address and password so they can check out your photos directly. Many people use this for weddings, birthdays, and other events. It is a great way for a whole group of folks to see all the photos from the event. Some sites even allow site visitors to order prints directly from the site operator.

Another version of this same idea is mail-order photo-finishing that then posts images to a secure web site. Again, you alert your friends and relatives and give them the password. These web businesses always take print orders and often offer special printing, such a mugs or mousepads.

Such sites are somewhat limited as to the sizes and arrangement of photos on a web page (as compared to your own web site), but they can be very convenient and cost very little to use. Check multiple sites to see how comfortable you are with their interface (how you interact with the site) and their features. Pick a site that seems to have some experience and staying power—find out who owns it, how new it is, and whether or not it seems to have good support.

▶ YOUR OWN WEB PRESENCE

The biggest advantage to doing your own web site is control over all the variables. You pick your domain name (check www.networksystems.com) and you decide on how photos will be used on the pages. The downside is that you now have to find a web-service provider, make up your pages, and upload them to the site yourself. Still, that can be well worth the effort if you want something that is truly unique to you.

Many programs are available today to make this process easier. Quite a few low-priced image processing programs, such as Ulead PhotoImpact® and MGI Photosuite®, include quite good, easy-to-use web capabilities. There are also more complex, but also more versatile, web-specific programs that are dedicated for web-site building. They can be worth trying if you need complete control and are willing to spend the time needed to conquer their learning curves. Whatever you use, plan to spend some time to master it.

Some web-site hosting companies will also provide their own web-site building software. Many Internet service providers (such as AOL or Earthlink) offer easy-to-use web site services. Try them out. You may find just what

The biggest advantage to doing your own web site is control over all the variables.

Many software programs make it easy to build your own web site (this is www.rsphotovideos.com).

you need. You may also find their web-site building software is rather limited in its photo capabilities.

A web site will obviously open up whole new possibilities for your photography; however, it can also be very confusing as far as using photos goes. The specifications needed for an image on the web are entirely different than those needed for a print:

1. Photos on the web are generally described in pixels because monitors have a size based on pixels. Every monitor can be set to different resolutions (pixel dimensions), so pixels are the only constant. Because many people have either smaller monitors or lower resolution, photos for the web are typically no larger than 640 pixels wide by 480 pixels (and often less) at 72 dpi.

2. You can either scan images directly for web use or you can resize your photo later. To scan directly for the web, you need to set your scanner to do a small scan. If you can set actual

pixels (check your manual or the help section of the software), scan so the image is no bigger than 640 horizontal x 480 vertical pixels in size—no one dimension should exceed this. If you do not have this option, try scanning at 72 dpi for an image output size up to 9x6.5 inches. If you have trouble with these methods, just scan your image the best you can at a low resolution and resize it in software.

3. You will often have multiple uses of your photos in mind, from web use to printouts. Good-looking prints and attractive, convenient web photos are, unfortunately, mutually exclusive. The print file must be big enough to give needed detail in the print, while the web image must be small enough to work properly on the web. Usually, photographers will scan to the largest size they will need, make a copy of the image file, then resize it specifically for the web.

4. The web needs an image at 72 dpi (dots per inch), which is a monitor resolution. Sometimes people refer to 640x480 as resolution—it actually refers to the area of the photo and can be considered an area resolution. The

Photos are great on the web, but keep pages simple because photos increase download time.

72 dpi is a linear resolution and refers to how the pixels are spaced in the photo.

5. You can always resize your photo in software. This will be under Size, Resize, Image or other menu choices (check your Help if you can't find it).

6. Once your photo is sized and adjusted, save the file as a JPEG compressed file. As with e-mail, JPEG reduces the file size so that the image is transmitted more easily across the Internet. Choose a JPEG setting that is toward the middle, but on the higher quality, lower compression side of the choices. The highest compression levels will significantly reduce your image quality.

7. Do not use GIF for your image files as it reduces the color quality of photos.

8. If you follow the method outlined above, 640x480 maximum size, moderate JPEG compression, your files should be small, under 100 MB. Check them. If they are bigger, re-save them at a higher JPEG compression.

Once your photo is sized and adjusted, save the file as a JPEG . . .

CONCLUSION

There is no one book that can possibly tell you everything you could know about digital photography from beginning (whether from a digital camera or a scanner) to the final print. Some "experts" will try to intimidate photographers by implying you really do have to know everything in order to get the most from this technology. Of course, you can't, so I suppose this makes them look good.

The possibilities of what the computer can mean for your photography are huge. And whatever works for you is right. You will discover more things as you go, and your craft will improve, but never let anyone make you feel inadequate because you can't do everything they can do.

Photography is a very personal form of art and expression. I hope you will enjoy your explorations into the digital world and bring back whatever works for you. I can tell you that it really is true that most photographers who begin on this path find it fun and exciting because of what it can bring to their photography. I wish the best of images for you, and lots of fun, as you try out the many possibilities open to you.

Photography is a very personal form of art and expression.

TECHNICAL NOTE

All slides and negatives in this book were scanned with a Minolta Dimage Scan Elite film scanner. They were photographed with Canon and Nikon cameras and lenses (along with Sigma lenses). Digital cameras used include the Olympus Camedia E-10 and Canon Power Shot G1.

ABOUT THE AUTHOR

Rob Sheppard is the editor of *PCPhoto* and *Outdoor Photographer* magazines. He has also worked as a naturalist, a photojournalist, a commercial photographer, and a video producer. His photographs have appeared in a variety of publications, from annual reports of Fortune 500 companies to national magazines. He is the author of *Computer Photography Handbook* and *Basic Scanning Guide,* both from Amherst Media. Visit his web site at www.rsphotovideos.com.

GLOSSARY

The following are important words to know and understand as you explore the combination of photography and computers.

Anti-aliasing—Using software to soften and blend rough edges (called aliased).

Archival storage—Using external, non-magnetic media such as CDs for the long-term storage of information.

Artifact—Defects in an image or other recorded data created by the tool used to record or output.

Athlon®—A microprocessor chip manufactured by AMD available in Windows-based computers.

Autofocus—The ability of the camera to focus its lens automatically.

Browser—(1) A software program that is used for examining sites on the World Wide Web; (2) a software program that is designed to show small, thumbnail images of digital files.

Byte—A packet of information that consists of 8 bits. Computers typically have 8-bit data pathways, making bytes the most efficient means of transmitting data or instructions.

CCD (Charge-Coupled Device)—A common type of image sensor used in digital cameras. The CCD actually only sees black & white images and must have red, green, and blue filters built into it in order to capture color.

CD-R, CD-RW—These are compact disk formats for storing data, and work very well for photographs. The "r" in CD-R stands for recordable, and this disk can be recorded onto once. The "rw" in CD-RW stands for

rewritable, and this disk can be recorded, erased, then reused by recording onto it again.

CD-ROM (CD-Read-Only Memory)—A compact disk that contains information that can only be read, not updated or recorded over.

Chip—Common term for a computer-integrated circuit, a key part of a computer.

Chroma—The existence of color in an image.

CMOS—Stands for complementary metal oxide semiconductor. This "chip" is used as a sensor in digital cameras. CMOS sensors use less energy than CCD chips.

CMYK (Cyan, Magenta, Yellow, Black)—These are the subtractive primary colors. They're used in so-called four-color printing processes used in books and magazines because they produce the most photo-realistic look for publications.

Continuous tone (CT)—The appearance of smooth color or black & white gradations, as in a photograph.

Copyright—A legal term that denotes rights of ownership and, thus, control over usage of written or other creative material. Unless otherwise noted, assume all images are copyrighted and can't be used by anyone without permission of the photographer.

CPU (Central Processing Unit)—The "brain" of a computer system. It consists of the main chip (Pentium®, Athlon®, G4®, etc.) and the necessary circuitry to transport information to and from it.

Data compression—The use of algorithms to reduce the amount of data needed to reconstruct a file.

Digital zoom—An over-hyped feature of digital cameras that takes a portion of the sensor's active area and digitally enlarges it to achieve the appearance, though not the quality, of a telephoto zoom.

Dot pitch—Typically used to evaluate a monitor's sharpness as a measurement of the distance between dots. A smaller number indicates a sharper monitor.

DPI (Dots per Inch)—Indicates resolution of a peripheral as a measurement of the number of horizontal or vertical dots it's able to resolve in input or output.

Drum scanner—A specialized scanner commonly used by the printing industry for very high-quality scans. It is very expensive and has a steep learning curve.

Dye sublimation (diffusion transfer)—Printing technology that results in continuous tone images by passing gaseous color dyes through a semi-permeable membrane on the media surface.

Dynamic Range—The difference between the highest and the lowest values in an image, as in the brightest highlights and the darkest shadows.

Feathering—Softening the edges of elements in an image by blending the effect across the edge.

File Format—A method for arranging the data that makes up an image for storage on a disk or other media. Standard image formats include JPEG and TIFF.

Film Scanner—Scanner dedicated to capturing image files from slides and negatives.

FireWire—A very fast connection (i.e., lots of data transmitted quickly) for linking peripherals to the computer; also called IEEE 1394 and i.Link®.

Flatbed scanner—Scanner designed to capture images from page-sized or smaller "flat art," including photographs and artwork.

GIF (Graphics Interchange Format)—A standard file format most commonly used for graphics on the World Wide Web. GIF reduces both resolution and color data, making it less effective for photography.

Gigabyte (GB)—A measurement of digital data approximately one billion bytes (1000 megabytes).

Gray Scale (or Grayscale)—A black & white image composed of a range of gray levels from black to white.

Inkjet—A low-priced digital printing technology where characters or images are formed by tiny droplets being shot at the paper.

Integrated Circuit—A highly engineered package of many circuits working together, usually in a computer chip; one building block of a computer.

Interpolation—A way of increasing the apparent resolution of an image by "filling in" the gaps between existing pixels.

JPEG (Joint Photographic Experts Group)—A file format used with photographs and other color bitmaps. The JPEG format "compresses" image information to create smaller files. JPEG files do lose image data (lossy compression) and, as compression increases, quality.

JPEG Artifacts—Image defects due to file size compression. These defects appear as tiny rectangles or squarish grain.

Kilobyte (KB)—1000 bytes of memory.

LCD (Liquid Crystal Display)—A display technology used for small monitors that act as viewfinders and playback display for digital cameras.

Lossless compression—Any form of file compression technique where no loss of image data occurs.

Lossy compression—Any form of file compression technique where some loss of image data occurs.

Magnetic media—Data storage media that uses magnetized particles imbedded in the media substrate to write and read data.

Megabyte (MB)—One million bytes of memory.

Megapixel—One million pixels in a digital camera sensor.

Optical media—Data storage media that uses a laser to write and read data; can be quite long lasting.

Optical resolution—The maximum physical resolution of a device. Optical resolution provides better quality than interpolated resolution, which uses software to create additional image information.

Pentium—A microprocessor chip manufactured by Intel® available in Windows-based computers.

Peripheral—A piece of hardware that's not part of the CPU and allows some important function of the computer, such as scanning or printing. Usually an external device.

Photo CD—A storage system for photographs developed by Kodak to use a CD as media; images can be added to CD at any time.

PictureCD—Another CD-storage system developed by Kodak and others to allow images to be put on disk at the time of processing.

Pixel—Short for picture element (pix/picture, el/element). The smallest element of a picture that can be controlled by the computer.

Plug and Play—A standard that allows a computer operating system to recognize a device and install it fairly easily.

PPI (Pixels per Inch)—The number of pixels per inch in an image, often used interchangeably with dpi.

RAM (Random Access Memory)—The computer's memory that's actually active for use in programs; comes on special chips.

Real time—The actions of the computer are seen at the same time as you perform them.

Removable media—Any storage system package that can be removed from the data drive, such as a Zip disk or CD-R.

Resolution—The density of pixels in an image or the number of dots per inch a device, such as a scanner, can achieve.

RGB—The primary color system of a computer based on red, green, and blue, the additive primary colors. Computer monitors display RGB-based screen images.

Ringing—White, ring-like border around distinct edges in a photo that occurs when that photo has been oversharpened.

ROM (Read-Only Memory)—A special type of permanent computer memory that can't be altered. It keeps its information even when the computer is shut down.

Scanner (drum, flatbed, or slide)—A sensing device that captures photos, slides, or negatives and translates them into digital files for the computer.

SCSI (Small Computer Systems Interface)—A very fast system that connects peripherals to the CPU; called a "scuzzie."

Sensor—The light-sensing part of a digital camera, usually a CCD or CMOS chip.

Service bureau—A business providing image services such as Photo CDs, slides, or large prints.

Thumbnail—A small, low-resolution version of an image.

TIFF (Tagged Image File Format)—An important and lossless bitmap image format common to most image-processing programs.

TWAIN—A standard protocol that allows communication from various types of scanners to the software.

Unsharp Masking (USM)—A sharpening technique that looks at contrasting edges within an image and intensifies them.

Video board—A part of the CPU that processes display information for the monitor.

Virus—A malicious implant some warped individuals put into software that can cause failures of systems including data or memory loss.

White balance—A metering function that tells digital and video cameras how to correctly represent color based on the color temperatures of different light sources. Many cameras have automatic white balance; some let photographers adjust it manually.

World Wide Web—That part of the Internet where text, pictures, and graphics come together in an integrated unit or page.

Zip drive—A drive developed by Iomega for storing information that uses 100 or 250 MB storage in removable media.

Zoom—Lens with a variable focal length, often wide-angle to telephoto, that allows photographers to change how much of a scene can be captured by the camera.

INDEX

OTHER BOOKS FROM
Amherst Media™

— DIGITAL IMAGING —

Basic Scanning Guide For Photographers and Creative Types
Rob Sheppard

This how-to manual is an easy-to-read, hands on workbook that offers practical knowledge of scanning. It also includes excellent sections on the mechanics of scanning and scanner selection. $17.95 list, 8 1/2x11, 96p, 80 photos, order no. 1708.

Beginner's Guide to Adobe® Photoshop®
Michelle Perkins

Learn the skills you need to effectively make your images look their best, create original artwork or add unique effects to almost image. All topics are presented in short, easy-to-digest sections that will boost confidence and ensure outstanding images. $29.95 list, 8 1/2x11, 128p, 150 full-color photos, order no. 1732.

Traditional Photographic Effects with Adobe® Photoshop®
Michelle Perkins and Paul Grant

Use Photoshop to enhance your photos with handcoloring, vignettes, soft focus and much more. Every technique contains step-by-step instructions for easy learning. $29.95 list, 8 1/2x11, 128p, 150 photos, order no. 1721.

Digital Imaging for the Underwater Photographer
Jack and Sue Drafahl

This book will teach readers how to improve their underwater images with digital imaging techniques. This book covers all the bases—from color balancing your monitor, to scanning, to output and storage. $39.95 list, 6x9, 224p, 80 color photos, order no. 1726.

Basic Digital Photography
Ron Eggers

Step-by-step text and clear explanations teach you how to select and use all types of digital cameras. Learn all the basics with no-nonsense, easy to follow text designed to bring even true novices up to speed quickly and easily. $17.95 list, 8 1/2x11, 80p, 40 b&w photos, order no. 1701.

Photo Retouching with Adobe® Photoshop®
Gwen Lute

Designed for photographers, this manual teaches every phase of the process, from scanning to final output. Learn to restore damaged photos, correct imperfections, create realistic composite images and correct for dazzling color. $29.95 list, 8½x11, 120p, 60+ photos, order no. 1660.

Outdoor and Location Portrait Photography
2nd Edition
Jeff Smith

Learn how to work with natural light, select locations, and make clients look their best. Step-by-step discussions and helpful illustrations teach you the techniques you need to shoot outdoor portraits like a pro! $29.95 list, 8 1/2x11, 128p, 60+ full-color photos, index, order no. 1632.

Lighting for People Photography, *2nd Edition*
Stephen Crain

The up-to-date guide to lighting. Includes: set-ups, equipment information, strobe and natural lighting, and much more! Features diagrams, illustrations, and exercises for practicing the techniques discussed in each chapter. $29.95 list, 8 1/2x11, 120p, 80 b&w and color photos, glossary, index, order no. 1296.

Wedding Photography:
Creative Techniques for
Lighting and Posing, *2nd Edition*

Rick Ferro

Creative techniques for lighting and posing wedding portraits that will set your work apart from the competition. Covers every phase of wedding photography. $29.95 list, 8½x11, 128p, full-color photos, index, order no. 1649.

Professional Secrets for Photographing Children
2nd Edition

Douglas Allen Box

Covers every aspect of photographing children on location and in the studio. Prepare children and parents for the shoot, select the right clothes capture a child's personality, and shoot storybook themes. $29.95 list, 8½x11, 128p, 80 full-color photos, index, order no. 1635.

Telephoto Lens Photography

Rob Sheppard

A complete guide for telephoto lenses. Shows you how to take great wildlife photos, portraits, sports and action shots, travel pics, and much more! Features over 100 photographic examples. $17.95 list, 8½x11, 112p, b&w and color photos, index, glossary, appendices, order no. 1606.

McBroom's Camera Bluebook, *6th Edition*

Mike McBroom

Comprehensive and fully illustrated, with price information on: 35mm, digital, APS, underwater, medium & large format cameras, exposure meters, strobes and accessories. Pricing info based on equipment condition. A must for any camera buyer, dealer, or collector! $29.95 list, 8½x11, 336p, 275+ photos, order no. 1553.

Essential Skills for Nature Photography

Cub Kahn

Learn all the skills you need to capture landscapes, animals, flowers and the entire natural world on film. Includes: selecting equipment, choosing locations, evaluating compositions, filters, and much more! $29.95 list, 8½x11, 128p, 60 photos, order no. 1652.

Wedding Photojournalism

Andy Marcus

Learn the art of creating dramatic unposed wedding portraits. Working through the wedding from start to finish you'll learn where to be, what to look for and how to capture it on film. A hot technique for contemporary wedding albums! $29.95 list, 8½x11, 128p, b&w, over 50 photos, order no. 1656.

Studio Portrait Photography of Children and Babies, *2nd Edition*

Marilyn Sholin

Learn to work with the youngest portrait clients to create images that will be treasured for years to come. Includes tips for working with kids at every developmental stage, from infant to preschooler. Features: lighting, posing and much more! $29.95 list, 8½x11, 128p, 90 full-color photos, order no. 1657.

Fine Art Children's Photography

Doris Carol Doyle and Ian Doyle

Learn to create fine art portraits of children in black & white. Included is information on: posing, lighting for studio portraits, shooting on location, clothing selection, working with kids and parents, and much more! $29.95 list, 8½x11, 128p, 60 photos, order no. 1668.

Black & White Photography for 35mm

Richard Mizdal

A guide to shooting and darkroom techniques! Perfect for beginning or intermediate photographers who want to improve their skills. Features helpful illustrations and exercises to make every concept clear and easy to follow. $29.95 list, 8½x11, 128p, 100+ b&w photos, order no. 1670.

Marketing and Selling Black & White Portrait Photography

Helen T. Boursier

A complete manual for adding b&w portraits to the products you offer clients (or offering exclusively b&w photography). Learn how to attract clients and deliver the portraits that will keep them coming back. $29.95 list, 8½x11, 128p, 50+ photos, order no. 1677.

Composition Techniques from a Master Photographer

Ernst Wildi

In photography, composition can make the difference between dull and dazzling. Master photographer Ernst Wildi teaches you his techniques for evaluating subjects and composing powerful images in this beautiful full-color book. $29.95 list, 8½x11, 128p, 100+ full-color photos, order no. 1685.

Innovative Techniques for Wedding Photography

David Neil Arndt

Spice up your wedding photography (and attract new clients) with dozens of creative techniques from top-notch professional wedding photographers! $29.95 list, 8½x11, 120p, 60 photos, order no. 1684.

Outdoor and Survival Skills for Nature Photographers

Ralph LaPlant and Amy Sharpe

An essential guide for photographing outdoors. Learn all the skills you need to have a safe and productive shoot—from selecting equipment, to finding subjects, to dealing with injuries. $17.95 list, 8½x11, 80p, order no. 1678.

Photographing Children in Black & White

Helen T. Boursier

Learn the techniques professionals use to capture classic portraits of children (of all ages) in black & white. Discover posing, shooting, lighting and marketing techniques for black & white portraiture in the studio or on location. $29.95 list, 8½x11, 128p, 100 photos, order no. 1676.

Dramatic Black & White Photography

SHOOTING AND DARKROOM TECHNIQUES

J.D. Hayward

Create dramatic fine-art images and portraits with the master b&w techniques in this book. From outstanding lighting techniques to top-notch, creative darkroom work, this book takes b&w to the next level! $29.95 list, 8½x11, 128p, order no. 1687.

Photographing Your Artwork

Russell Hart

A step-by-step guide for taking high-quality slides of artwork for submission to galleries, magazines, grant committees, etc. Learn the best photographic techniques to make your artwork (be it 2-D or 3-D) look its very best! $29.95 list, 8½x11, 128p, 80 b&w photos, order no. 1688.

Posing and Lighting Techniques for Studio Photographers

J.J. Allen

Master the skills you need to create beautiful lighting for portraits of any subject. Posing techniques for flattering, classic images help turn every portrait into a work of art. $29.95 list, 8½x11, 120p, 125 full-color photos, order no. 1697.

Studio Portrait Photography in Black & White

David Derex

From concept to presentation, you'll learn how to select clothes, create beautiful lighting, prop and pose top-quality black & white portraits in the studio. $29.95 list, 8½x11, 128p, 70 photos, order no. 1689.

Watercolor Portrait Photography

THE ART OF POLAROID SX-70 MANIPULATION

Helen T. Boursier

Create one-of-a-kind images with this surprisingly easy artistic technique. $29.95 list, 8½x11, 128p, 200+ color photos, order no. 1698.

Techniques for Black & White Photography

CREATIVITY AND DESIGN

Roger Fremier

Harness your creativity and improve your photographic design with these techniques and exercises. From shooting to editing your results, it's a complete course for photographers who want to be more creative. $19.95 list, 8½x11, 112p, 30 photos, order no. 1699.

Corrective Lighting and Posing Techniques for Portrait Photographers

Jeff Smith

Learn to make every client look his or her best by using lighting and posing to conceal real or imagined flaws—from baldness, to acne, to figure flaws. $29.95 list, 8½x11, 120p, full color, 150 photos, order no. 1711.

Professional Secrets of Natural Light Portrait Photography

Douglas Allen Box

Learn to utilize natural light to create inexpensive and hassle-free portraiture. Beautifully illustrated with detailed instructions on equipment, setting selection and posing. $29.95 list, 8½x11, 128p, 80 full-color photos, order no. 1706.

Portrait Photographer's Handbook

Bill Hurter

Bill Hurter has compiled a step-by-step guide to portraiture that easily leads the reader through all phases of portrait photography. This book will be an asset to experienced photographers and beginners alike. $29.95 list, 8½x11, 128p, full color, 60 photos, order no. 1708.

Professional Marketing & Selling Techniques for Wedding Photographers

Jeff Hawkins and Kathleen Hawkins

Learn the business of successful wedding photography. Includes consultations, direct mail, print advertising, internet marketing and much more. $29.95 list, 8½x11, 128p, 80 photos, order no. 1712.

Master Posing Guide for Portrait Photographers

J. D. Wacker

Learn the techniques you need to pose single portrait subjects, couples and groups for studio or location portraits. Includes techniques for photo-graphing weddings, teams, children, special events and much more. $29.95 list, 8½x11, 128p, 80 photos, order no. 1722

The Art of Color Infrared Photography

Steven H. Begleiter

Color infrared photography will open the doors to an entirely new and exciting photographic world. This exhaustive book shows readers how to previsualize the scene and get the results they want. $29.95 list, 8½x11, 128p, 80 full-color photos, order no. 1728.

The Art of Photographing Water

RIVERS, LAKES, WATERFALLS
STREAMS & SEASHORES

Cub Kahn

Learn to capture the dynamic interplay of light and water with this beautiful, compelling and comprehensive book. $29.95 list, 8½x11, 128p, 70 full-color photos, order no. 1724.